HOW TO PAINT

DRAWING TECHNIQUES

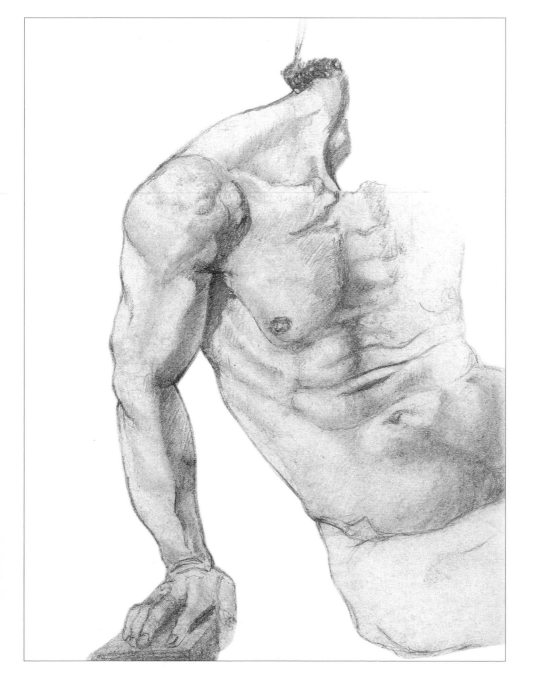

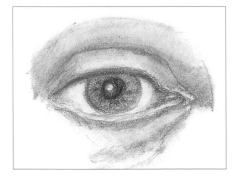

Dedication

For my fourteen grandchildren – from the eldest, who has forgotten more about classical drama than I shall ever know, to the youngest who had learned by his second birthday to balance a teaspoon on the end of his nose. May art, in its diverse forms, always be central to their lives.

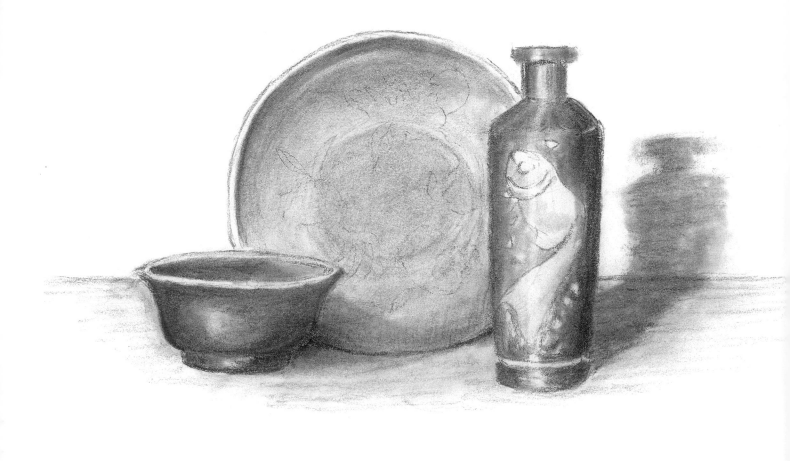

HOW TO PAINT
DRAWING
TECHNIQUES

QUENTIN DE LA BEDOYERE

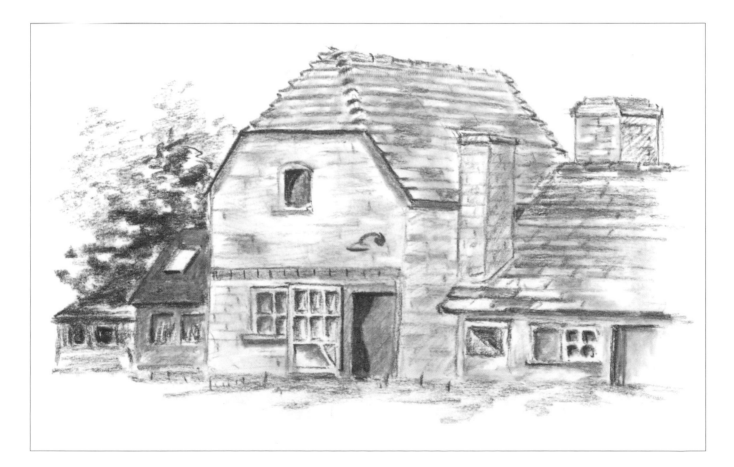

SEARCH PRESS

First published in Great Britain 2008

Search Press Limited
Wellwood, North Farm Road,
Tunbridge Wells, Kent TN2 3DR

Reprinted 2009, 2011, 2014

Suppliers
If you have difficulty obtaining any of the materials and equipment
mentioned in this book, you can telephone Winsor & Newton
Customer Service on 020 8424 3253 for details of your
nearest stockist.

Alternatively you can visit the Search Press website:
www.searchpress.com

Acknowledgements

*My thanks to Sophie Kersey, Managing Editor
at Search Press, who has succeeded gracefully
in turning my undisciplined fervour that
people should draw into an orderly and
comprehensible layout.*

*My general thanks to all those whose pictorial
work has inspired my drawings, but in
particular to the Old Masters from whom I
first learned what drawing could do.*

Publishers' note

All the step-by-step photographs in this book feature the
author, Quentin de la Bédoyère, demonstrating drawing
techniques. No models have been used.

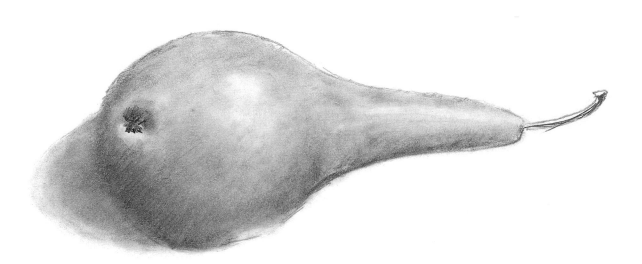

Printed in Malaysia

Contents

Introduction

This book is for those who have always wished they could draw, or have tried a little drawing and find they need some basic help. It has been written to enable you to cut a few corners in getting started, and to guide you in the right direction. From the stone age cave until today, humankind have had the urge to draw – to accomplish that seeming miracle of making marks on a two-dimensional surface which communicate to the viewer our image of the three-dimensional world.

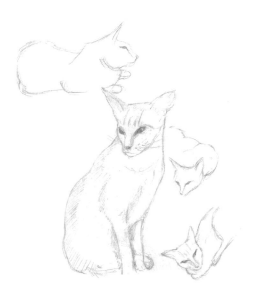

If you close your eyes and rummage around your desk or table, there is a good chance that your fingers will alight on a pencil. Look a little further, and you will find some blank paper – it may be the back of an unwanted document or spare space on an old envelope. With those two items, you have the necessary instruments to create a drawing which will rival Michelangelo at his finest, or less ambitiously, simply record a detail of the truth of reality.

If you think you might be too old to begin, then think of me in my sixth decade flying to Montreal. Out of boredom I began to copy a head of a young woman in a book of da Vinci's drawings. I just copied what he did, and when I finished I knew I could draw. I keep that mediocre sketch to this day, as a reminder that it is never too late to start.

A good drawing is one which lives. That is, it springs out at you and engages your emotions and your imagination. It may be highly sophisticated or as crude as a few lines in the wet sand before the tide comes in. Of course this is a personal judgment: a drawing may be alive for some and dead for others. All you can do is to make drawings that live for you; that should be enough. And, even when you have become skilled, you will produce a dozen dead drawings for every live one. Something intangible and marvellous happens when eye, hand and brain – leavened generously with luck – come together to make a live drawing. Never throw it away; it has earned the right to survive because it now has a life of its own.

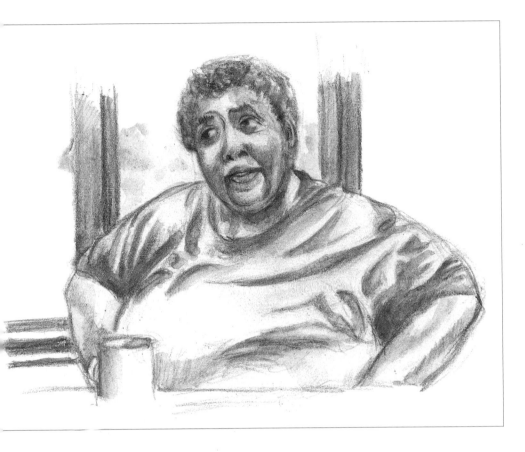

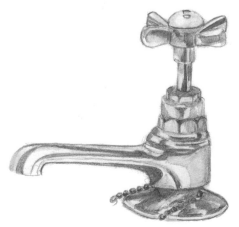

There is only one route to becoming a good artist: practice. We vary in our ability to coordinate hand and eye, but most of us find this hard. I certainly do. Like the concert pianist, we have to practise every day. You can draw someone on a railway platform or in a waiting room; you can draw a rubbish bag by the side of the road while waiting for a bus; you can draw a tree from a park bench while taking the sun. I defy you to look around you and not find something which is worth drawing. And, as you practise, your hand will become more skilled; before long it will achieve that special quality of line that marks the trained hand of the artist.

Every sketch in this section was casual. That is, I saw something that caught my eye – and pencil and paper were at hand. Some took less than a minute: none of them took more than fifteen minutes.

Materials

Many art shops are well stocked, and will often order additional items for you from their catalogue. Try out the materials before you buy whenever possible. Some large stationers also carry a limited stock, and may be cheaper. Other suppliers use mail order catalogues. But start by buying the minimum you need, and extend with experience. If you are attending an art course, fellow students will exchange tips on sources, and your tutor will help. Do not forget that various minor art materials can be found in a normal household.

Pencils

Graphite pencils are the most flexible of drawing instruments; they can make the lightest mark or the darkest shade. They can be erased, within reason, thus allowing you to work boldly, without fear of mistakes. They are available in many degrees of softness: ranging from 9H (very hard) to 9B (very soft). The far ends of the range are specialist, and you will not need them. I suggest that you start with HB, B and 2B pencils, and then extend and experiment. You will notice that the softer the pencil, the more it is inclined to smear. This is a good quality because, carefully controlled, it is a good way to shade.

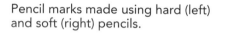

From left to right: cheap propelling pencil; clutch pencil which can take various inserts; six standard drawing pencils of varying grades and a 2B solid graphite pencil.

Pencil marks made using hard (left) and soft (right) pencils.

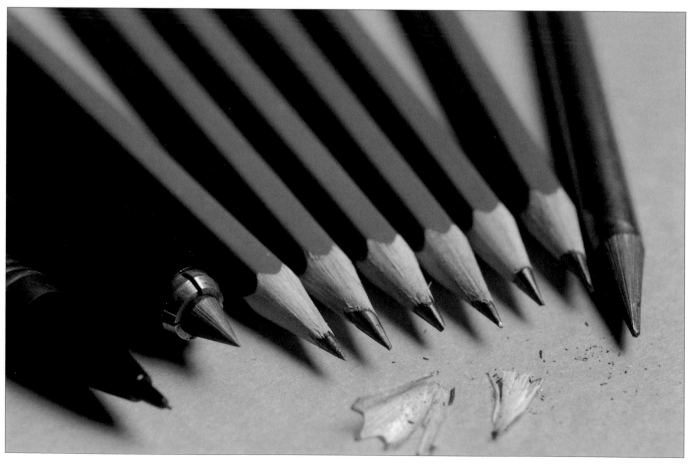

I have sat for many hours reading under the dappled light of this tree on Wimbledon Common. It deserved a drawing. I started with a rough, light outline of the tree, and I noted its overall structure with care, because this was to be indicated by the changing direction of the bark. I started from the top to avoid smudging with my hand, and I revised several times as I worked my way down. Finally, I used the putty eraser to refine light and shade, both in the detail and in the overall picture. On the Contents page, you can see how this drawing started.

Charcoal

Charcoal is the most natural of media, and one of the most satisfying in which to draw. Fine, detailed work is possible but it is well suited to bold, swift drawing. You can buy packets of sticks in diameters from thin to thick, but you would do best to start with an assorted packet and experiment.

Charcoal is very soft, and, despite its strong line, it is easy to blend. In fact it is almost too easy: you will need plenty of practice, but perseverance will give rich rewards. It will also give you a dirty carpet and dirty fingers, so choose your workspace with care. Unless you are framing immediately, you will need to 'fix' charcoal (see page 15) to prevent damage.

Charcoal pencils are a useful alternative, and certainly more convenient for carrying around. They are less flexible than the sticks, and many find them a good compromise.

Compressed charcoal can give an intense shade, and can easily be used for fine work. But it is more difficult to erase and blend. Use with care.

Charcoal sticks and a charcoal pencil.

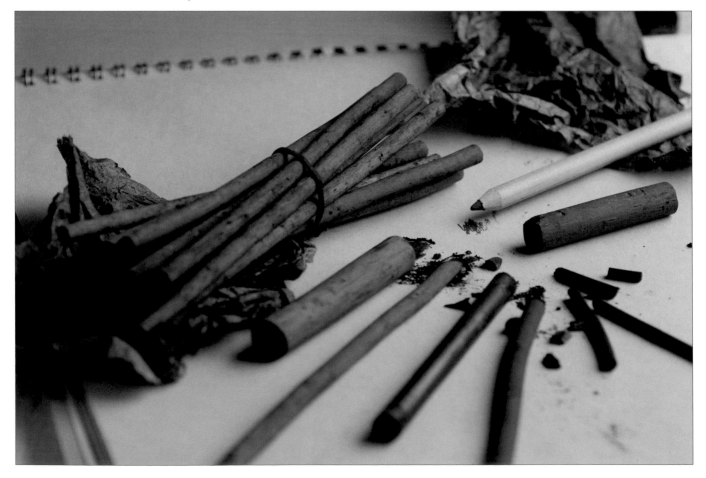

This drawing was done using raw charcoal, paper tissues, a stump and erasers on light grain cartridge paper.

Drawing the human figure is a high point for the artist. You will find help in technical books for artists which illustrate the underlying anatomy, because you have to show not only the surface but also suggest what lies beneath. Of course any medium can be used but the capacity of charcoal to show subtle shading makes it especially suitable.

Sanguine pencils and crayons

The word sanguine means 'blood-coloured'. Sanguine pencils come in different, but related, shades. Take your pick. You can also buy crayon sticks known as Conté carrés crayons. The stick form is very useful for large, bold drawings, and is a classic artist's instrument. Sanguine pencils and crayons erase and blend well, but not so easily as graphite pencil, so they are a little harder to use.

I think sanguine has a touch of class, perhaps because of its association with the Old Masters.

Sanguine pencils and Conté carrés crayons.

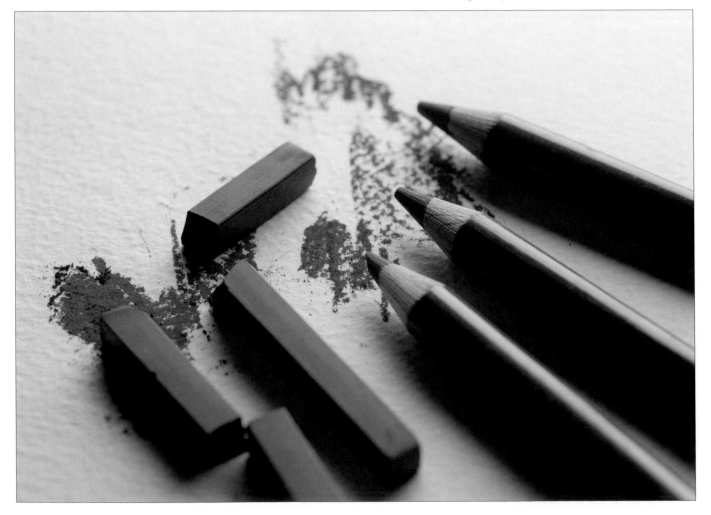

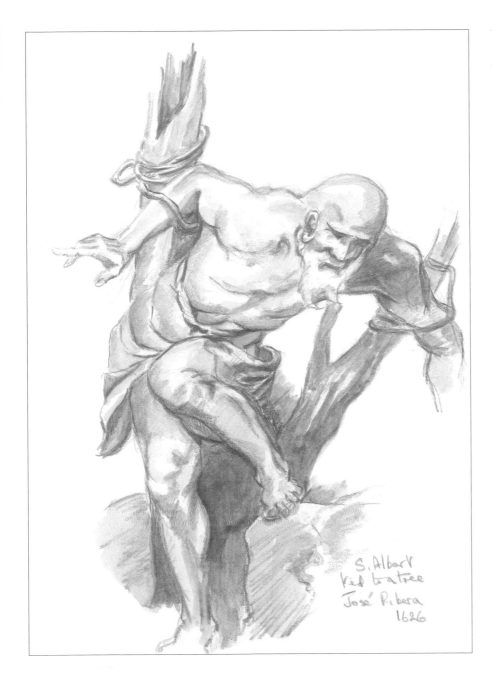

This drawing is a direct copy of St Albert, by the Spanish artist José de Ribera, 1591–1652. His nickname was 'lo spagnoletto' or 'little Spaniard'.

S. Albert
tied to a tree
José Ribera
1626

The drawing below was done using sanguine crayon, erasers and a stump on 300gsm (140lb) grey Not paper.

This picture is of my own hands. My wife took several photographs, from which I picked the most suitable as my model. If you analyse the picture, you will see that in fact the fingers are based on articulated cylinders, and, in this case, I started with just such a construction.

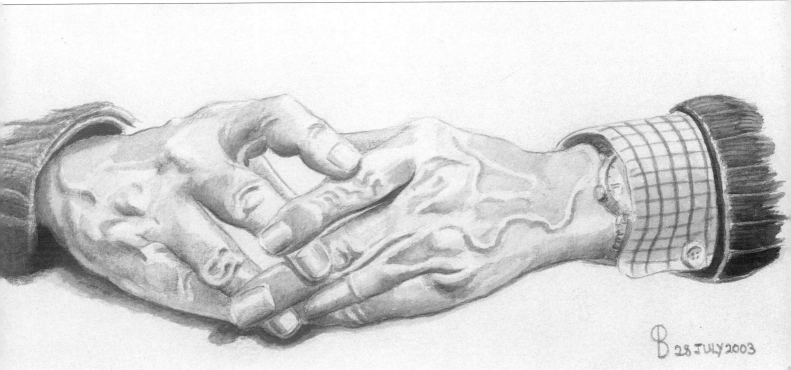

28 JULY 2003

Paper

Your drawing surface will usually be paper, although there is nothing to stop you from using, say, cardboard. Cartridge paper sketchbooks are the easiest choice. The weight of the paper should be between 135gsm (63lb) and 220gsm (100lb). It can be smooth or lightly grained. A good size to choose is A4 or A5, and I have a special fondness for A6 because it fits in my pocket, ready for an instant sketch. You can also buy much larger separate sheets, which are more economical but require cutting to the size you need.

I am fond of using heavy paper, (300gsm/140lb), which has a distinct grain called, for technical reasons, 'Not'. This is really designed for watercolour but it is excellent for a special drawing. It can be white or in two or three light shades. I favour the grey, which is particularly well suited to sanguine crayon.

At the cheaper end of the scale, a pad of large A2 size paper, such as the flip charts used in drawing classes and presentations, provides a good surface for really expansive, arm's length drawing. I also favour stationer's A4 blank file paper. It is so cheap that you can afford to waste it. Last, but by no means least, the back of an envelope. The artist with itchy drawing fingers will use any surface readily to hand.

Cartridge paper sketchbooks in various sizes, 300gsm (140lb) Not watercolour paper in various shades, ordinary A4 file paper and an old envelope, all suitable for drawing.

Other materials

Cotton buds These are useful for fine blending, especially charcoal.

Putty eraser A kneaded putty eraser is not just for correcting mistakes; it is a drawing instrument in its own right. The putty eraser can be squeezed into different shapes. You can press it down to lighten shading, flick a highlight on spectacles, or remove your original guidelines.

Pencil-top wedge eraser These are useful for blending and lightening. You can of course use any good quality eraser, but the pencil-top type is always with you, and just the right shape.

Fixative Most drawings need to be fixed, and a spray-can fixative is most convenient. I have often used hard-to-hold hair fixative in moments of necessity. Several light applications at intervals are best. Always use in a well-ventilated room.

Craft knife Use a craft knife for sharpening pencils and crayons. It can also be used sometimes, in extremity, to scratch a highlight in, say, an eye.

Sandpaper This is useful to refine a point on a wood-encased sanguine crayon and essential for shaping an edge on charcoal or a conté stick. Medium grade is best.

Sticky desk-top notes These are useful to mask your drawing when hard erasing is needed.

Stump or **torchon** This is a pointed stick of paper fibre. Use it for blending.

Paper tissue Keep a box by you. Never drive acid into your paper by rubbing a drawing with your finger. Rub through a paper tissue. These are very useful when you are using charcoal.

Ink eraser For careful use in emergencies. I prefer the pencil form, which can be sharpened to a rough point. There is a brush on the other end for removing bits.

Clockwise from top left: sticky desk-top notes, putty erasers, stumps, sandpaper, cotton buds, an ink eraser, a craft knife, pencil-top wedge erasers and paper tissue.

Spray fixative.

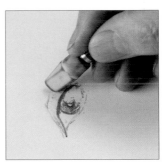

Above: a stump being used for blending pencil. Below: a pencil-top wedge eraser being used to remove sanguine crayon.

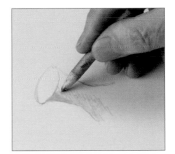

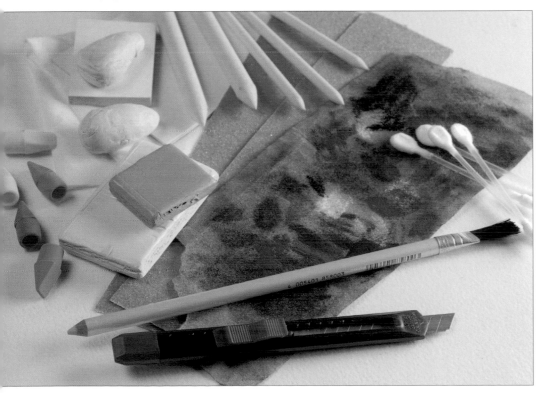

Observation

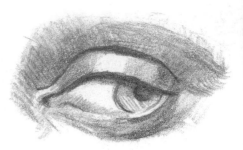

Developing the artist's eye

The gift of artists to the world is a special way of seeing. Everywhere they look they are trying to identify aspects of physical reality which can make a picture. It may be something as simple as loose coins on a dressing table or the turn of a staircase. It may be as complex as an interesting human form, a cat in a basket, or the skyline of a city. They are sensitive to form, line and angles, and above all they are interested in dark and light. It is their job to see the physical in all its relationships more deeply than others do, so that they can portray their vision – just as poets are more sensitive to emotion so that they can express it in words. What, for instance, would be the difference if you drew an eye simply from your memory, or drew it from close observation? Here are three eyes: one based on Picasso, one based on da Vinci, and one by me. The contrast demonstrates the nature of close observation.

I drew this eye in the style of Leonardo da Vinci.

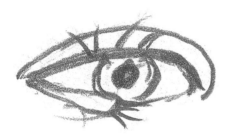

I drew the eye on the left in the style of Picasso.

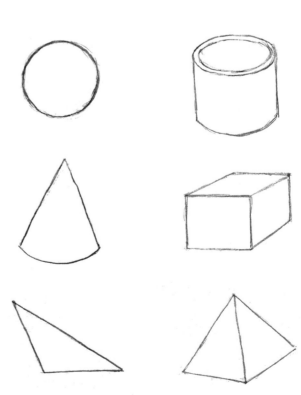

The eye on the right was drawn from close observation.

Analysis of basic shapes

When I received my first, and very few, art lessons at school, I was required to practise basic shapes: squares, circles, blocks, triangles, cones and so on. I thought it was a great waste of time. No one had explained to me that the artist carries the basic shapes in his mind and, when looking at a scene, he uses them to find structure.

In the early days an artist may start by drawing these basic shapes and then developing the picture by recording the variations. But with increasing practice he may not need to bother with planning on paper; instead he mentally projects the shapes on to the scene and works directly from there. But he may still need to draw them if a picture is complex, or the shapes in the scene hard to disentangle.

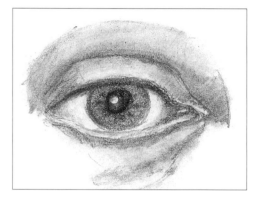

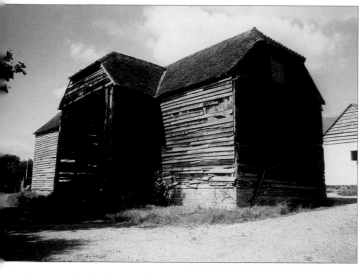

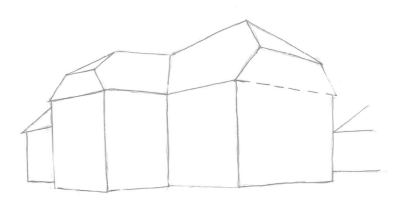

I spotted this barn when I was motorcycling in Surrey. I loved its shape, and the fact that it was well used and a little shabby – much more attractive than a modern barn.

This could have been a quite complicated drawing without using my basic shapes. But, as you can see from this rough sketch, analysis was straightforward. Do not concern yourself with the perspective (we will come to that later); just decide if it looks roughly correct.

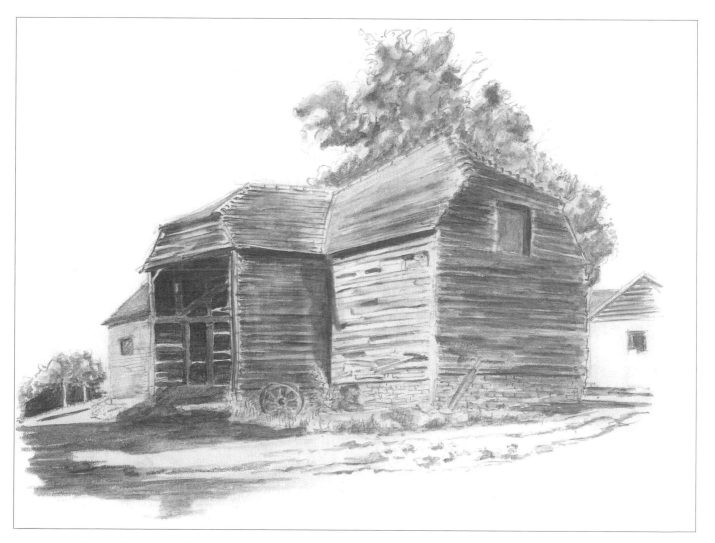

Here is the finished drawing of the barn. You can see how it relates closely to my shape analysis. Notice, for reference later on, that I have aged it and, by using a little foreground and background, given it composition, placing it firmly in its country setting.

Observing line

Line in itself can be beautiful. For example the treble clef is a musical symbol which pleases the eye with its curves and convolutions. But line performs a particular function in drawing: we see the drawn line (which is not usually present in nature) and, by a complex brain mechanism, we convert it into a recognisable object. So observing the line with great care and expressing it in the drawing is half the battle won. Often we will look for beautiful lines but it is perfectly proper to use awkward and ugly lines when what we wish to show is awkward and ugly.

Some artists draw the lines they need quite naturally, but most of us have to practise over and over again. I cannot tell you how many treble clefs, circles, eggs and straight lines I have drawn to educate my hand. It is a good use of time while you are using the telephone.

Ballet is all about line – which must express both held pose and movement. This sanguine crayon drawing (right) shows us more than the beautiful outline made by the dancer; it also shows the internal lines such as the musculature of the arms and stomach. If you look carefully, you will see how some lines have been strengthened to suggest shadow: for example, the bottom line of the horizontal arm.

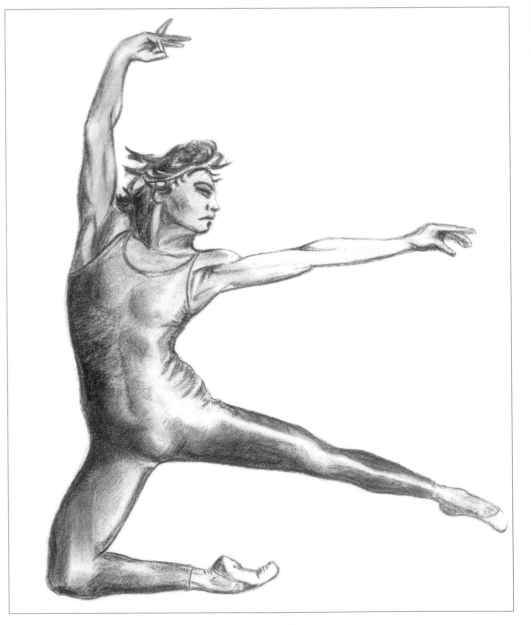

Well drawn line can give you a three-dimensional impression without any shading whatsoever. My next example (above, left) is a part-sketch of Giambologna's 16th century sculpture which is in the centre of Florence. It has no shading, and I have not strengthened lines to help me here. But the more important lesson it demonstrates is the intersection and angle of the lines. There are at least seven major intersections in this simple drawing, and every one contributes to the effect which the artist intended.

Observing light and shade

Drawing is all about the interplay between light and dark in their various gradations; we have no variation of colour to interfere with the purity of our observation. So we have to get good at it, down to the subtleties which lay viewers are not capable of distinguishing because they have not developed the artist's eye.

Try an experiment. Look through a pinhole in a piece of card at a plain wall which appears to have a constant shade of light. If you change your point of focus to several different positions you may be surprised to find how much variety there is in the fall of the light. Already you are developing the artist's eye.

Techniques for observing light and shade

The oldest technique is the simplest and the best. Look at a scene through screwed up eyes. Try out of the window now. The distracting detail is lost, the darks get darker and the lights get lighter. Always do this before starting a picture to get a visual summary of the light patterns. Also check frequently throughout the drawing process.

In the sketch below of priceless, antique Chinese objects, you will see shadow in the objects themselves, and the shadow which they cast on surrounding objects. Notice how the shadow of the 'fish' vase climbs the wall behind, and also how it gets fainter and vaguer in the distance. I drew this on file paper in charcoal pencil, and used a putty eraser to get the highlights. I had reference photographs but no priceless objects, so I used a bowl, a plate and a bottle of washing up liquid as a mock-up to show me how the shadows worked.

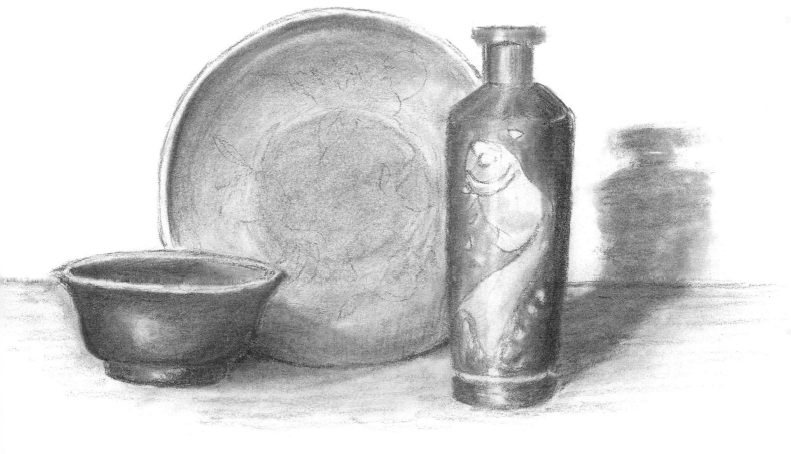

Techniques

There are no rules for techniques; artists develop their own according to their needs. This section is designed to give you no more than a starting point from which to develop. The techniques are as multiplication tables to arithmetic, or grammar to English; they are no more than the means to serve your creativity.

Beginning to draw

A sheet of blank paper, a pencil in hand, and an object to draw. Where do you start? Here is a very simple demonstration: drawing a pear. Do not be misled by its simplicity. If you can draw a tolerable pear, you can draw almost anything.

1 Visualise your object in terms of the basic shapes we have looked at, and draw them in lightly. The pear is easily analysed in this way into a circle, or rather a ball, and a cone.

2 Noting variations from the shapes, draw your initial outline. You will see how the circle and the cone have been modified to match my object. But I have left a hint of the original circle to remind me of its basic shape. I have also noted the positioning of the 'eye', which will be an important feature.

3 Now, screwing up your eyes, observe the lights and darks, recording or remembering approximately where they go. Notice that I have marked the direction of the light. This will remind me throughout the drawing. But it also enables me to gauge the extent of the cast shadow, using a simple line. And I have also marked the highlight points. Those on the ball and the cone are obvious, but I have also marked the light reflected on to the pear from the surface on which it is resting, and on the dimple of the 'eye'.

Scribble shading

Scribble shading is freehand shading in which you put your shading lines in whatever form suits the job best. You can of course shade over dark portions several times, use a different grade of pencil, and be ready with your putty eraser. It may sound rough and ready, but you can get quite sophisticated results.

Here I have completed the scribble shading of the pear. I have kept approximately to the light and shade I have observed. You will see how the dimpled 'eye' has become clear. Notice how the cast shadow is strong close to the pear but lightens at a distance. This can now be considered a finished drawing.

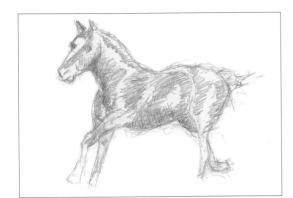

Here, working with an HB pencil, I have sketched in a horse, and begun to build up the key shadow patterns. I have deliberately worked lightly to allow for alterations as I move into the next stage.

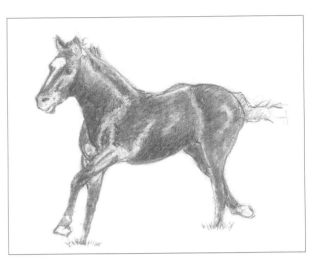

At this point I decided to switch to a 2B pencil. The horse is black so the softer lead will give me the tone I want. It will also help me to smooth out my scribble shading. While I had tried to preserve the sheen by leaving the paper white, I found, as usual, that my putty eraser was needed to get this just right. I firmed up the lines and did a general tidy up before I finished.

Cross hatching

This is a common method of using close lines for shading either for a whole drawing or for parts of it. It can be done speedily or with care – depending on the effect you require. The example I show here is a tree in the public gardens in Basingstoke.

1 Here I have analysed my tree into it basic cylindrical shapes. You will see how I have marked the joints to show me how the branches change direction.

2 At this stage I have got my outline and identified the key details. I have also drawn in a few contour lines just to remind me how my hatching will need to go. Notice how clearly I have, for instance, indicated the joining of the biggest branch to the trunk.

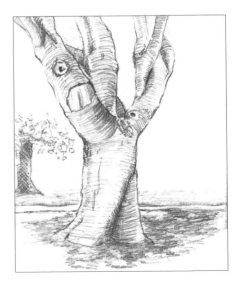

3 Here is the finished drawing. I have used straight cross hatching lines for the tiny tree in the background, but I have curved them deliberately on the main tree. You will see how they contribute to its three-dimensional shape.

Blending

While scribble shading in different strengths and directions is a useful way to achieve gradations of shade, you may prefer, as I often do, to blend your shades to achieve a more finished drawing. The principle is quite simple: having applied your drawing instrument to give a rough shading, you then smooth it out and adjust the gradations to just the level you need. The principal tools you will use are a stump and erasers. However, the different drawing instruments vary in their blendability, and you will need to practise each medium to bring it under your control.

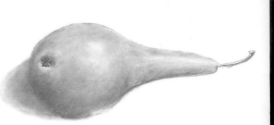

The scribble shaded pear from page 20 with the shading blended.

Pencil

The softer the grade of pencil, the easier it will be to blend. However, the more it blends, the more it is likely to smear, so great care is needed, and use a good fixative when you have finished. The tools I use are a stump, an ordinary eraser (I prefer a pencil-top wedge eraser), and a putty eraser. In the demonstration below I have used my favourite pencil, a 2B.

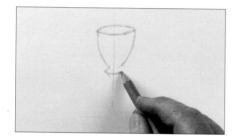

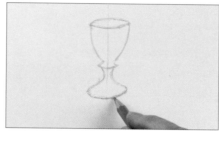

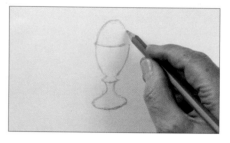

1 Lightly draw a vertical line first. This will help you to keep the lines of the egg cup symmetrical. Draw the perspective oval at the top. The kink in the egg cup stand should be a deeper oval than the top one, as it is further below your eye line.

2 Draw the perspective oval at the bottom, which should be deeper still.

3 Rub out the vertical line and the line at the back of the egg cup's rim, then draw in the egg.

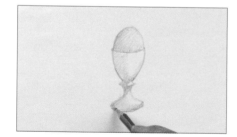

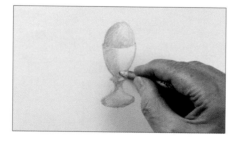

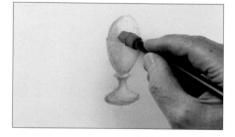

4 Decide where the light is coming from and begin shading, roughly indicating the lights and darks. Thicken the edges below the cup to suggest shade.

5 Use a stump to blend the pencil shading.

6 Make sure your pencil-top eraser is clean by rubbing it on some clean paper. Use it to lift out shading, creating a highlight on the egg.

7 Refine and clean up the drawing. Add more shading under the kink in the egg cup stand. Squeeze a putty eraser into an egg shape and use it to lift out highlights.

The finished drawing.

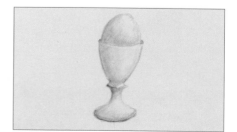

Charcoal

Charcoal, especially in its natural form, has a much higher blendability than pencil, so mastering it needs plenty of practice and cheap paper. I supplement a stump and eraser with paper tissues and, for fine work, cotton buds. Get the point you want with sandpaper rather than a craft knife.

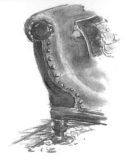

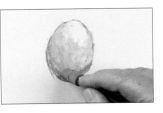
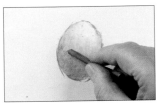
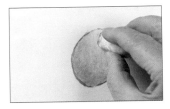

1 Sharpen your charcoal on sandpaper. Draw the outline and begin shading, strengthening the left-hand side and bottom of the egg and reserving light towards the top right.

2 Use the pencil-top eraser to take out quite a bit of the shading. How much you take out depends on how much pressure you apply.

3 Add a little more shading and more weight to the lines on the shaded side and bottom.

4 Use a putty eraser to lift out a little charcoal if the lines are too strong, to clean up the drawing and to add a highlight.

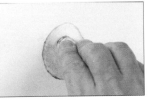

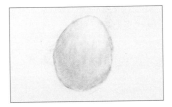

5 Press the putty eraser gently over the whole drawing.

The finished drawing.

Sanguine pencil

The technique here is similar to graphite pencil, but sanguine pencil is a little harder to erase or blend, so use a light touch until you are sure that the lines are right. Make your original shading as smooth as possible so that the blending will be easier.

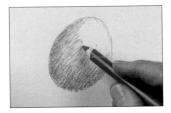
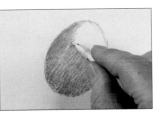
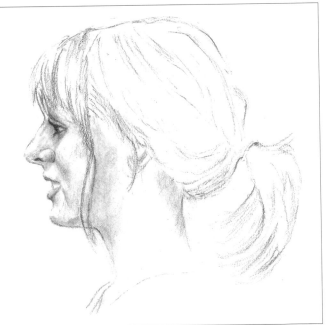

1 Lightly draw the outline of the egg and begin the shading.

2 Blend the shading using the stump. Keep a separate stump for sanguine work.

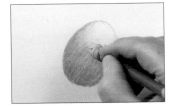
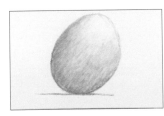

3 Working from the top down, continue blending and grading using the pencil-top eraser.

4 Strengthen the outline and add a horizontal line to show that the egg is at an angle.

This profile of my granddaughter at age fifteen is an example of the delicacy you can achieve with this medium. If you get a sense of how I feel about this elegant young lady, my picture will have succeeded.

Composition

Composition is largely a matter of the eye. A well-composed picture gives pleasure to the eye by being balanced and harmonious. It also enables us to understand the picture easily because it guides the brain to see it as a whole. Good composition will often be dynamic, giving the picture life and movement. In paintings we are accustomed to viewing a complete, rectangular composition: in drawing we may be looking at an individual object – but even that object on its own must be well composed.

Refining your composition skills

A useful tool is a card with a viewing rectangle made from two L-shaped pieces of card. Combining these in different ways, look around the room or at the garden. You will see some views which attract your eye, and some which displease; good composition versus bad composition.

Use the card when you are planning an actual drawing. It will tell you quickly where your borders should be, and indicate where you might improve on reality by moving or changing parts of the picture.

Examples

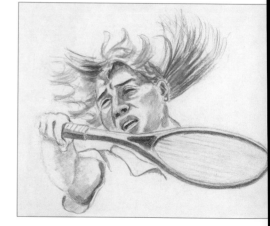

Imagine this picture of Steffi Graff in her young days with the tennis racquet removed. All the interest in the picture would be on the left-hand side, and the shape would be awkward. Replace the racquet which, taken on its own is much less interesting than the player's face, and suddenly the picture balances.

Now look at the two cello players. They seem disconnected even though they are roughly parallel. You would think they could have been drawn quite separately. Then see them against the background of the other players. They are still the most prominent, perhaps even more so because of the sketchier treatment of their colleagues. Now we have a harmonious, in both senses of the word, group – and the two cellists connect naturally to each other.

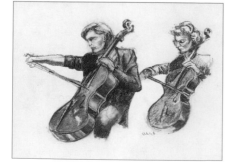
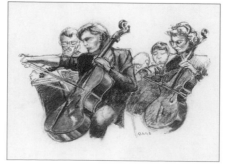

Compositional sketches

An invaluable method for planning your composition is the compositional sketch. Having reviewed the subject you are considering, follow this up by making small, rough drawings – experimenting with variations on the composition until suddenly, you hope, your eye will spot that you have it just right. Compositional sketches should be very free, and take no more than a few seconds. I sometimes do half a dozen or more before I hit the jackpot.

Here is the scene I had in front of me. Lovely to look at on a summer afternoon but far too messy to draw. What interested me? The big tree and the water seemed a possibility, so I tried a compositional sketch. Like the others on this page it was about 5 x 6cm (2 x 2³/₈in) and all three were done on a single sheet of file paper.

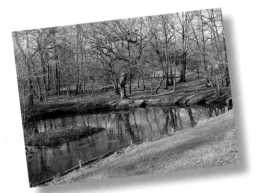

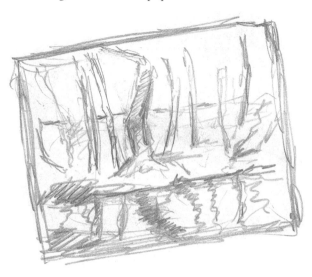

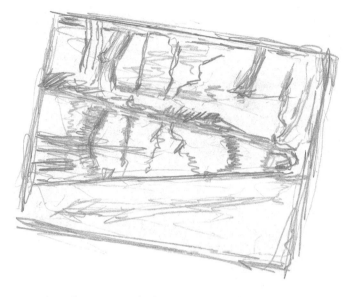

In this first sketch the tree was there, right in the centre, but – other than as a portrait of a distant tree – it seemed rather dull. It needed a different approach.

I am happier with this one. Now I have my tree about a third into the picture. This is a good position for a feature in a composition, as the Ancient Greeks discovered. I like the diagonal of the foreground, but it is simply too big. It takes the emphasis away from my real focus. So I will try another variation.

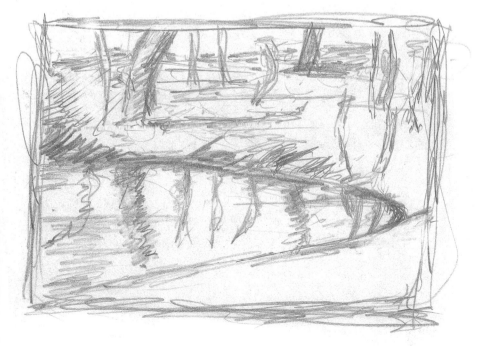

That's more like it. The foreground is reduced, and I find that I have drawn a 'Z' pattern, which unifies the picture. I tighten this up a little. My tree is prominent, and made more so by the dark tree in the background, but it remains part of the whole picture. Now it is time to abandon my cheap file paper and start the real thing in my sketchbook.

Surfaces and textures

Achieving credible surfaces and textures is great fun, and there are plenty of opportunities for practice. Careful observation, as usual, is required and also the ability to convey an impression rather than a detailed, and perhaps fussy, treatment. The examples I provide here are only representative: experiment with different surfaces until you find good ways of indicating them.

Shiny surfaces

These are easier than they look. All it takes is having faith to draw what you see. Remember to screw up your eyes at an early stage, and then get down to the detail. In this drawing there is the gleam of the basin, the chrome of the taps, and the transparent tap handles. They are set off by the relative dullness of the soap and the razor. My putty eraser, squeezed to a fine line, was invaluable for those little sparkles which bring the drawing to life. It was drawn in a boring bed-sitter in Devon, which just shows that interesting subjects can be found anywhere.

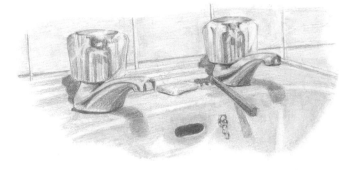

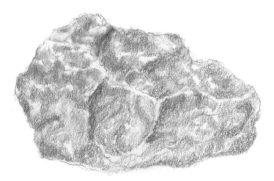

Rocks

Rocks vary a great deal, showing their history and geology in their shapes. A convincing drawing requires careful attention to this. The effects are achieved mainly through light and shade. This rock, which I just went out into the garden to draw for you, was about half a metre long (1½ feet), and I drew it on A6 paper, with a 2B pencil and scribble shading.

Ruins

I could simply have taken a photograph of the scene shown here, and this splendid relic of the ancient world would be lying forgotten somewhere in an album. Instead, it is deep in my memory, and I feel that in some way I own it because I have drawn it. I have used the varied fall of light to show the great, worn blocks. The pillars still speak to us of grandeur, and added touches such as the ground, the fallen pillar (note the perspective) and the foliage, complete the composition without distracting us from the main image.

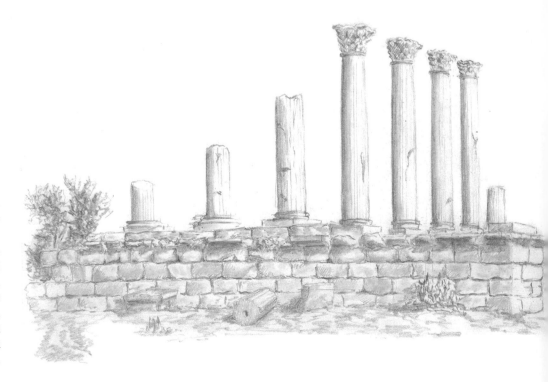

Fur

This was another 'occasional' drawing, which I did during a longish telephone conversation. You will notice how I suggested fur by the perimeter of the drawing – leaving you to import it into the picture. Probably the hardest part was getting the ear facing out towards me to look natural, but I was most pleased with the fact that I caught this kitten's character – and completed the telephone conversation!

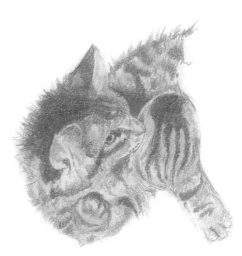

Drapery

This is a surface which you will encounter frequently, so I have done a study for you based on Bernini's sculpture of Teresa of Avila. (Working from the Masters is a time-honoured way of learning difficult techniques.) While this was a challenging drawing, it follows the same sequence I have described, that is: a light outlining with an indication of the major shadow areas, followed by careful drawing and blending using a stump and pencil-top wedge eraser. Then of course my great saviour – the putty eraser. The test of drapery is whether the viewer can sense the weight and feel of the material. Does my study pass the test for you? Incidentally, Leonardo did studies of drapery on its own, just for practice. So unless you are better than Leonardo, take a leaf out of his book.

Perspective

Get perspective into perspective. Some artists, in the early stage of development, get into a great tangle of construction lines, when the fundamental instrument is the eye. Have you noticed that a photograph of, for instance, a person whose foot is stretched out to the camera gets distorted? In fact the photograph is formally correct, but the human eye adjusts automatically, and so it is the more reliable guide. If the perspective of your picture looks right, then it probably is right, so my examples here are deliberately basic.

There are two kinds of perspective used in drawing: aerial perspective and linear perspective.

Aerial perspective

This is shown by the way that as objects recede into the distance, they get relatively fainter and the detail reduces. Here is a simple, exaggerated example. This effect can be used over quite short distances. Aerial perspective in monochrome is a particular challenge because you lack the painter's advantage of being able to use the way colours change with distance.

Although the picture is imaginary, it is worth noticing that it preserves the direction of the light at each receding stage.

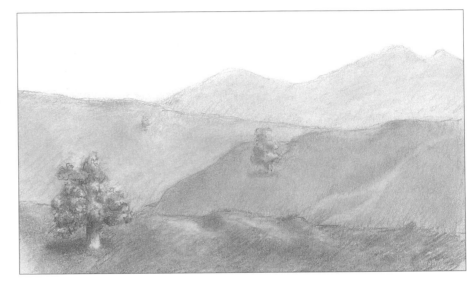

Linear perspective

Linear perspective imagines a horizontal line based on the artist's actual view. Receding objects which are above this line slope down towards it: those below slope upwards. This is known as two-point perspective, and it is most easily seen in the simple diagram of a building shown below.

However, note another factor. On the right hand face of the building I have drawn diagonals from the corners. This has enabled me to find the central line of the face in correct perspective, and I have used it to establish the point of the roof. The same construction can be used for any rectangle in perspective, for example, centring the point of a gothic arch.

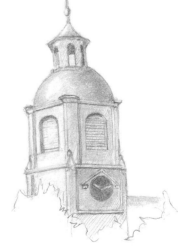

This is a handsome church tower at Hampton, near Hampton Court Palace. It shows two point perspective quite clearly. But I judged this by eye, so no rulers to check me, please!

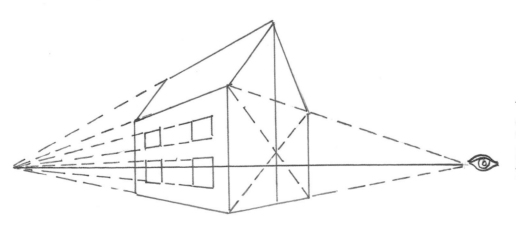

Cylindrical objects, like bottles, follow the same basic rule but it is harder to apply. It is best to use your eye here, as I did for my coffee mug. For the diagrammatic bottle I put my eye line in the centre so that you could see how the top curves downwards, and the bottom upwards. I drew in the bottom of the label to show you the variation between the top and the bottom. Until you are confident of your hand and eye, I suggest that for a sanguine drawing you start with very light pencil lines, which you can easily erase and repeat until you have the shape that looks right.

Take any opportunity to draw cylindrical objects that come your way, and so develop your skill. I drew the coffee mug with raw charcoal on file paper during a commercial break on the television – so I practise what I preach. Note that the mug is well below the eye line.

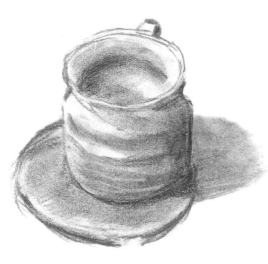

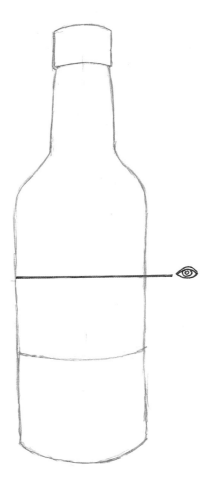

This sketch was drawn from the other side of the Grand Canal in Venice. I was standing roughly opposite the third gondola from the left. Given the charming, higgledy-piggledy nature of Venetian building over the centuries, constructing perspective lines defeated me. I had to work by eye. You judge whether I got it close enough.

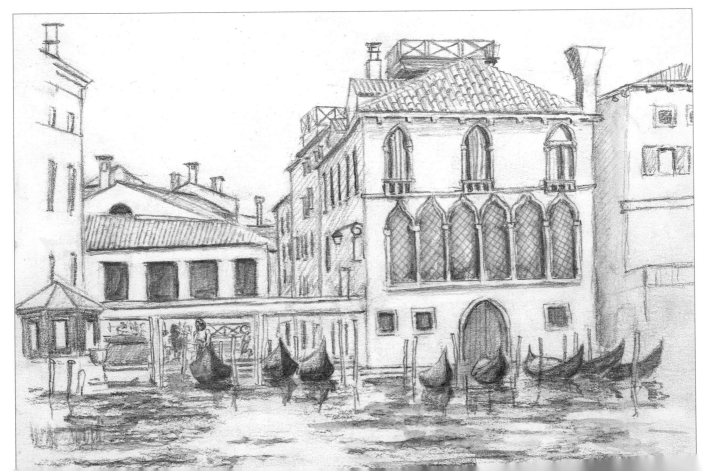

A pencil drawing

The Boatyard at San Trovaso, Venice

This drawing was done with 4B and 2B pencils, a stump and erasers on
135gsm (63lb) cartridge paper. San Trovaso is a small canal leading off the
Grand Canal. The boatyard has recently been refurbished and, in my view, lost
some of its atmosphere. So, in a way, this is an historical picture. I love this
scene and have drawn it often. I was attracted by the relationship between the
pragmatic craftsmen and the beauty of their product.

The appearance of random decay
is not easy to achieve. Stumping
and erasing can help.

This very black background
throws the foreground
boats into high relief.

These simpler boats show up
the beauty of the gondola,
but in fact they were much
harder to draw convincingly.

Note the cast shadows
of all the boats, and their
reflections in the water.

This is a picture of men at work, so the figures need to be credible. A limited degree of caricature can give character.

On second thoughts I should have drawn this top row of buildings much more loosely. Fortunately, I think the rest of the picture is strong enough to carry them.

Great care is needed to recreate the beautiful line of a gondola, reinforced by shading. Note how the stern is offset to counteract the weight of the gondolier.

This is where the 4B pencil was useful. Several applications were required. Notice how the slight gradation of the dark shows that some light gets inside.

A charcoal drawing

The Old Palazzo

This drawing was done using natural charcoal, charcoal pencil, paper tissues, a stump, erasers, cotton buds and fixative on 135gsm (63lb) cartridge paper. This was an opportunity to do a strong charcoal drawing. The medium is well suited to old buildings, which benefit from a degree of informality. The old and broken often make the best pictures – would a neat suburban semi have been as interesting?

The composition is symmetrical but the symmetry is varied by details, and by the gondolas and the water. I think it works.

I planned the picture carefully so that I could work from the top and avoid smudging with my hand. I also used fixative as I went. In charcoal (and other tender media) fixative can become a drawing instrument, and not just a finishing touch.

Notice how ageing is shown impressionistically by random detail.

I achieved these strong blacks by fixing first, re-charcoaling and fixing again.

These curtain folds were achieved using a putty eraser. The lifted curtain in the opposite window is a detail which helps to vary the symmetry.

The reflections in the water are mirror images. Their fuzziness indicates the amount of movement in the water.

Suggested objects in these dark rooms bring them to life.

Careful grading of shades shows curves.

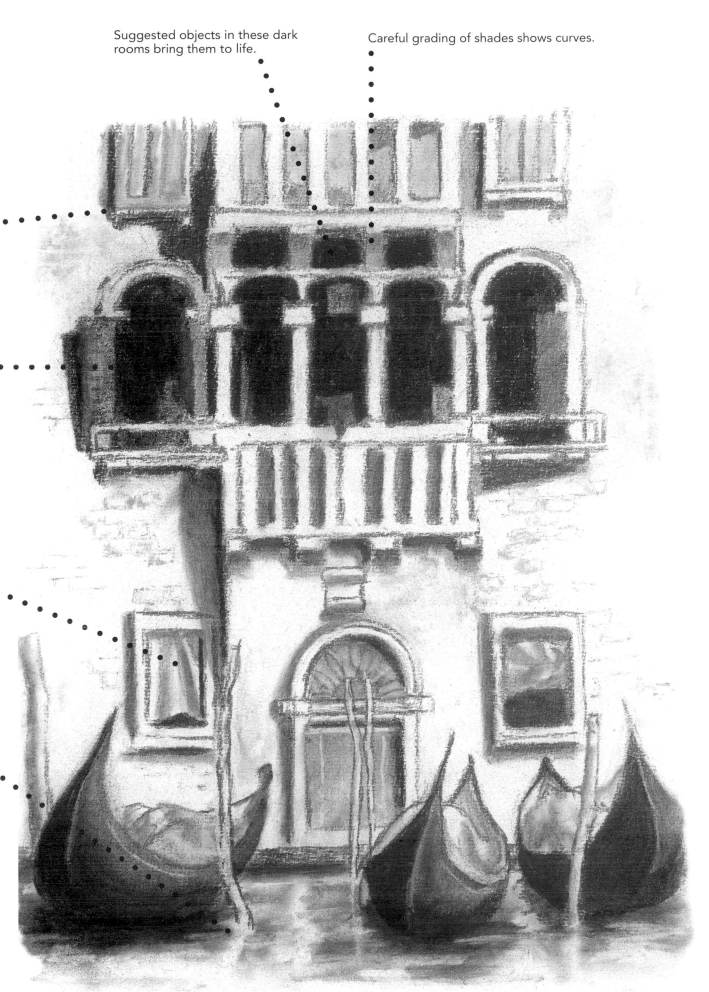

A sanguine crayon drawing

Mont Saint-Michel

This drawing was done using sanguine crayon, a stump, erasers and sticky desk-top notes on 135gsm (63lb) cartridge paper.

The abbey of Mont Saint-Michel, which is about a kilometre (five-eighths of a mile) off the Normandy coast, is a dramatic sight. My challenge was to give a well-known scene a new impact by exaggerating the contrasts of light and shade, and clarifying the structure through simplification. I also wanted to enhance its grandeur by increasing its appearance of isolation.

I prepared by doing some pencil sketches so that I was clear about the structure, and started by drawing very lightly in sanguine crayon.

Getting the right weight of shadow and the corresponding lights is key throughout this drawing.

It is always hard to get the right tonal value for windows. Note how shadow and light can do the trick.

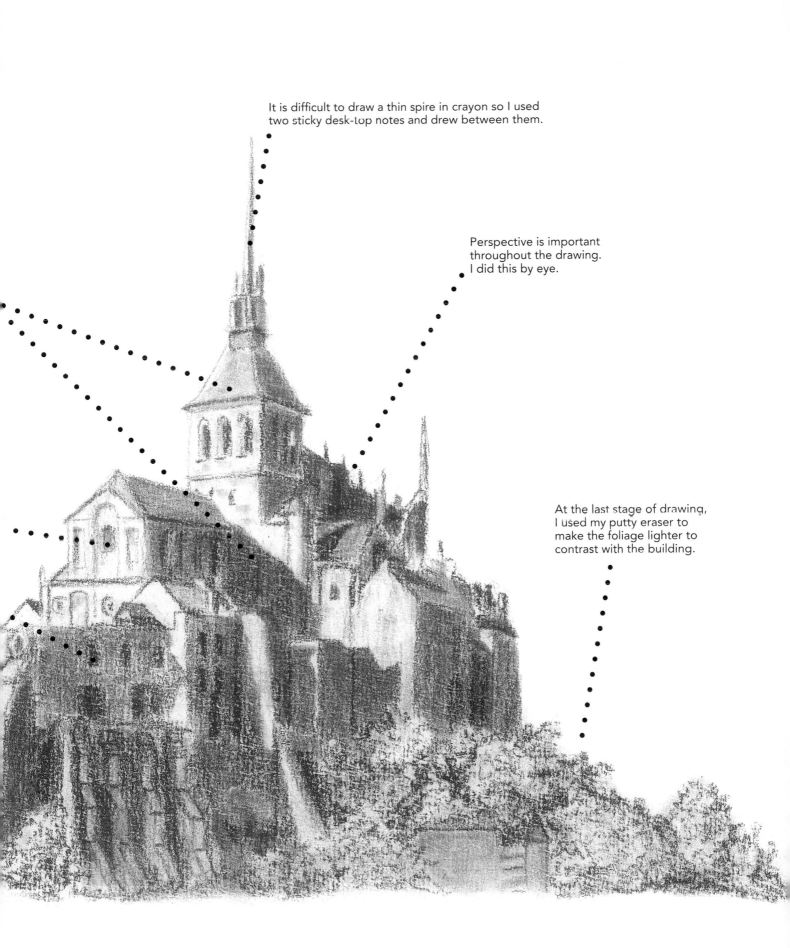

It is difficult to draw a thin spire in crayon so I used
two sticky desk-top notes and drew between them.

Perspective is important
throughout the drawing.
I did this by eye.

At the last stage of drawing,
I used my putty eraser to
make the foliage lighter to
contrast with the building.

Demonstrations

The best way for me to show you how a drawing may be made is to demonstrate it step by step, so I have chosen some pencil, charcoal and sanguine subjects to draw for you. They are relatively simple drawings, but you will find that the principles involved can be used for much more complex work. Do remember that this is a teaching exercise, which I hope will be a good starting point for you. It is, however, only a starting point: you will quickly develop your own methods – and break all the rules, just as it suits. The object is to develop your own style, because that is the way that you will do your best drawing.

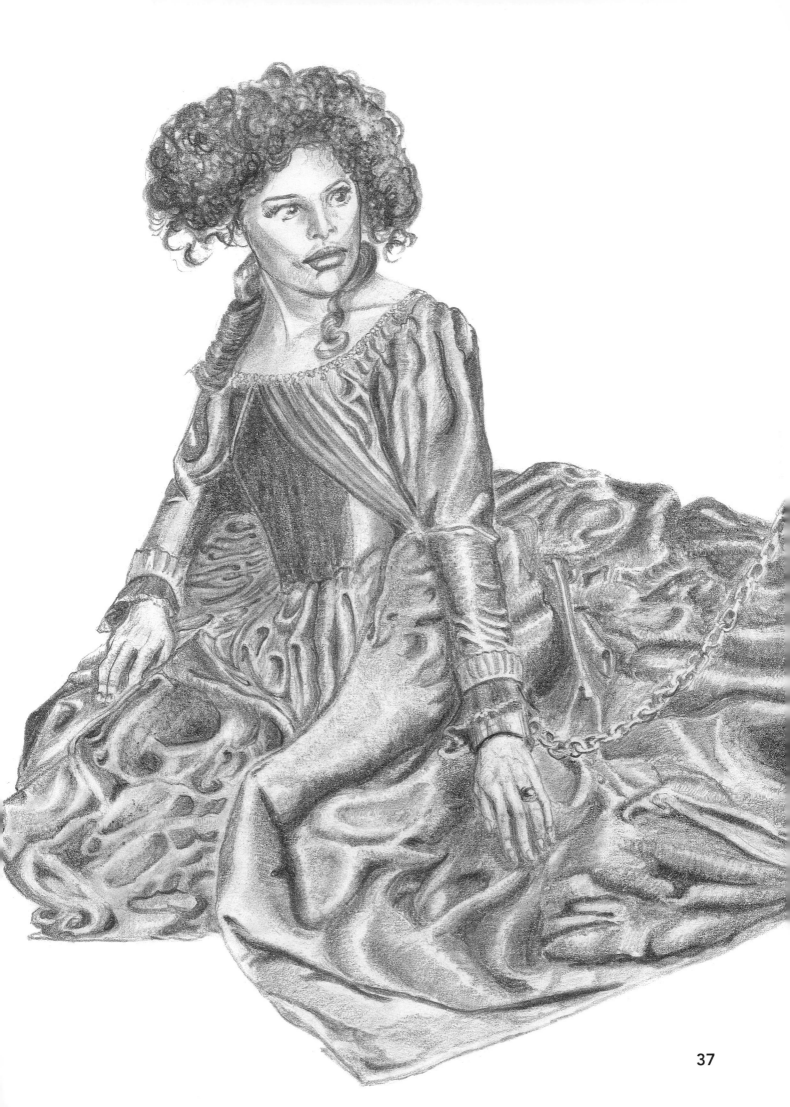

Venetian Building

As I worked through the stages of this drawing, I had the whole scene in my mind's eye, and so I knew just what each part had to do. I recommend that, with this and the following demonstrations, you momentarily flip over the page and look at the finished drawing first, and then look at what I do at each stage. You will then see how each stage was drawn in the light of the overall effect I was trying to achieve.

Since I was working in pencil I did not need to worry about making mistakes, but you will see that every stage needed several decisions to get it to play its correct part.

You will need

2B pencil
A4 file paper
Pencil-top wedge eraser
Putty eraser
Stump

1 Draw vertical and horizontal axis lines, to help keep your drawing straight. Hold the pencil near the end and roughly place the building's main shapes, working freely with broad strokes. When drawing the arch, draw a central line to help you get the symmetry needed.

Tip
Start the main detail of a drawing from the top, to prevent you from smudging your work with the heel of your hand as you draw.

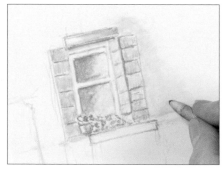

2 Work on the top window first. Use shading to create a contrast between the light window frame and the dark areas of the glass. The light is coming from the left, so although the shutter on the left is in shade, its edge catches the light. The double shutter on the right needs two different degrees of shading. Use a stump to soften and blend. Create foliage in the window box with scribble shading and add flowers, some dark and some light. Shade the wall and blend it with the stump.

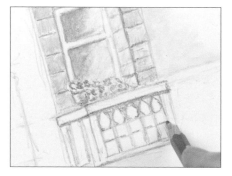

3 Draw in the balcony. You will need to consider a tiny bit of perspective where the balcony goes back to the wall. Draw the straight parts first, then begin work on the dark shapes between the uprights. When working on the shaped uprights, draw construction lines across to help with the position of the first and second bulb shapes.

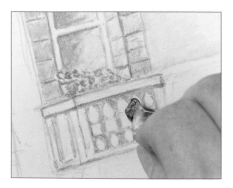

4 Complete the bulb shapes at the bottom and press the area with a putty eraser to take back the strength of the darks.

5 Shade the bulb shapes and then lift out highlights with a putty eraser. Note that the front of the balcony is darker than the side.

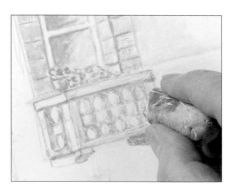

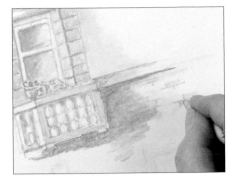

6 Add deep shade beneath and to the right of the balcony. Roughly draw the odd brick, and use the stump to create a weathered look.

Tip
When the stump is charged with graphite after blending, it can be used to add soft tone to a drawing.

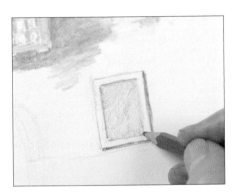

7 Draw the right-hand window quickly. Show that the frame stands proud of the wall by adding dark shading on the right-hand side and bottom. The inside left-hand side and top of the frame should also be quite dark, since the light is coming from the left. Shade the whole glass area light grey.

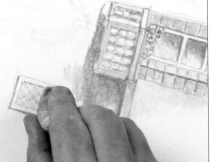

8 Create a blade shape with your putty eraser and use it to rub off diagonal lines across the glass area. Turn the paper and do the same again to suggest cross bars.

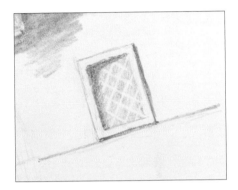

9 Shade the top and left-hand side of the pane.

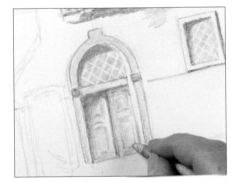

10 Draw in the outline of the door frame. Shade in the inside of the archway and create cross bars as for the small window. Draw a dark, central line between the doors, and add shading to the doors to create panels. Shade the top and left-hand side of the arched doorway inside the frame. Use a stump to blend. Preserve the highlight on the inside of the right-hand upright.

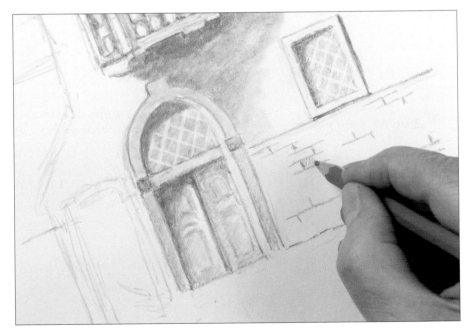

11 Extend the shading down from the balcony and round the edge of the arch, and use the stump to blend. Draw in the waterline. Suggest brickwork with a few random pencil marks and cross hatch to shade some areas.

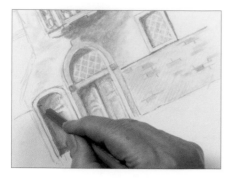

12 Draw the archway on the left, shading darkly on the left and at the top as before. Use the stump to blend the shading.

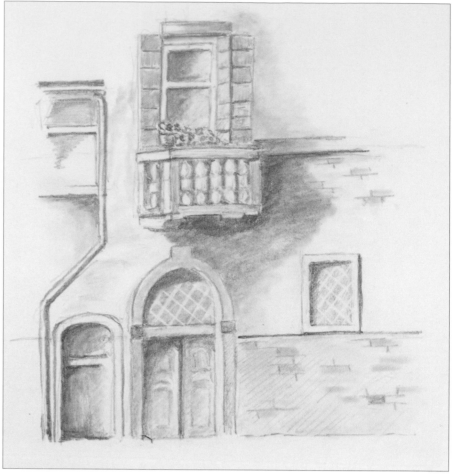

13 Draw the pipe and the window on the left-hand side, and add shading. The main part of the drawing is now complete, with only the water left to add.

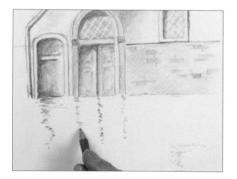

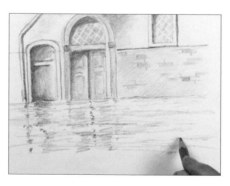

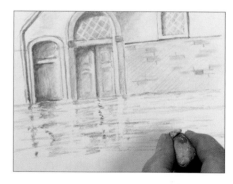

14 Begin to draw the main reflections. Work horizontally and indicate the degree of flux in the water by suggesting ripples. Draw the reflection of the dark line in the middle of the door. Add a rippled reflection of the darkness around the left-hand door. The uprights of the door frame cast a lighter reflection. Add a very light reflection of the right-hand window.

15 Draw the reflection of the pipe. Now add broad horizontal strokes across the water.

16 Use the putty eraser to lift out a reflection of the highlit part of the door frame. In the same way, lift out random ripples with quick flicks across the water.

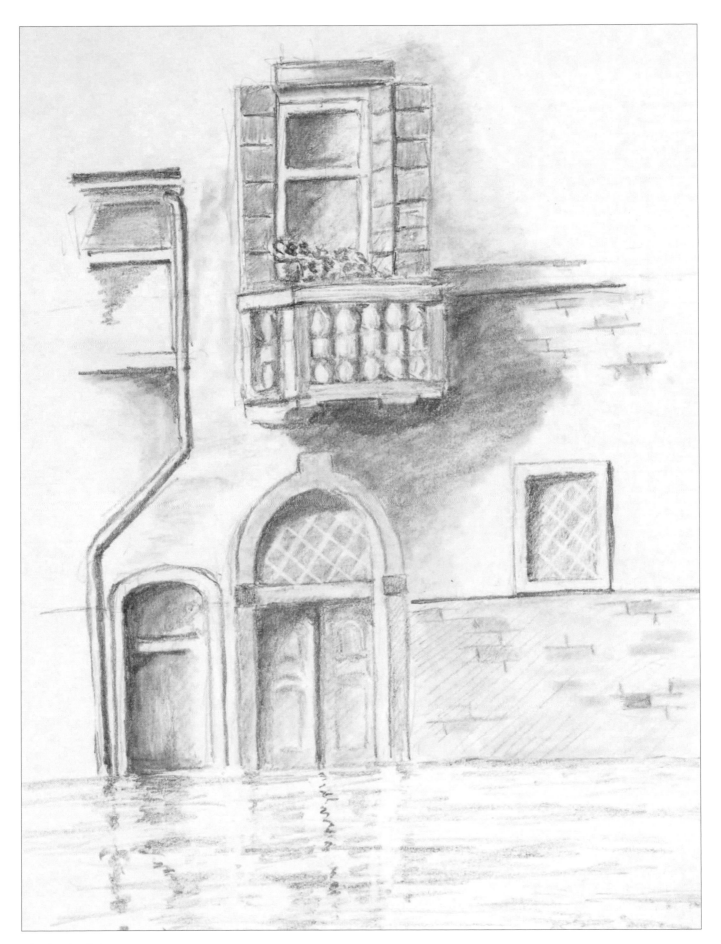

The finished drawing.

Angler

I was sitting on a bench by a stream, listening to a radio programme when my drawing fingers got itchy. My obvious model was the angler who looked set for a long stay. However, by some strange telepathic process, the quickest way to ensure that people move away is to start drawing them. So I ignored the background and drew in the figure at double speed with particular attention to his profile and to the complicated lines of his camping chair. However, by the time I had completed step 3, the telepathy had worked, and he left.

Luckily I had just enough information on paper and in my memory to complete the drawing. Notice that my cheap propelling pencil has its own eraser – which is an excellent substitute for a blending stump in moments of need. I put in the background at leisure, and went home for tea.

You will need

Propelling pencil with B lead and eraser
A5 sketchbook
Putty eraser

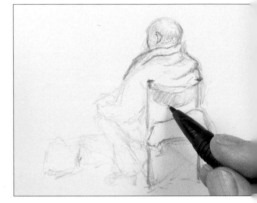

2 Begin to add detail, paying particular attention to the head, which in this case is slightly balding and suggests a man in his fifties. Add the ear. Start on the shape of the clothes with loose cross hatching and scribble shading. The light is coming from the right, so shade the left-hand side. The chair has a kind of 'skirt'. Shade the top of the chair back, making it darker away from the light.

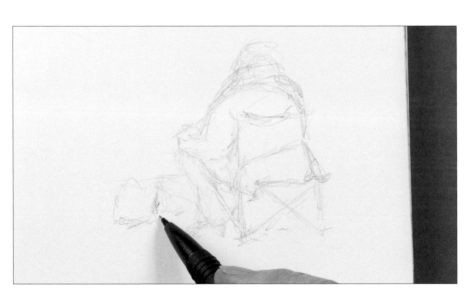

1 Quickly sketch the outline of the man and the chair. I also sketched in the box and bags at this stage, in case the man removed them.

3 Draw in the crossed chair legs; it might help to imagine them on the sides of a box. Pay attention to where they catch the light. Carefully shade the 'skirt' below the chair back, noting that it curves up on either side, catching the light. Use the putty eraser to re-establish the highlights, especially on the right.

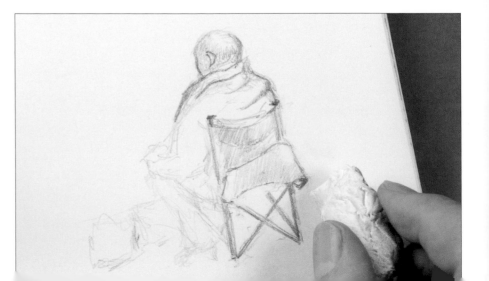

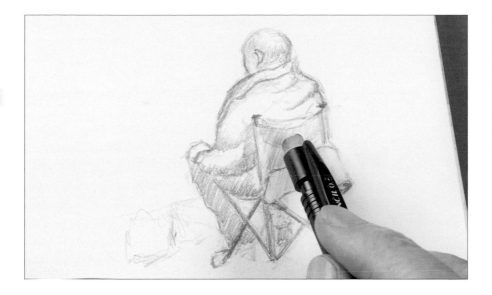

4 Shade the arm of the angler's baggy old jacket, and put the hand in simply, without detail. Put in the crossed legs on the left of the chair, remembering to imagine them on the side of a box to help you with the perspective. Draw and shade the trousers. Use the eraser on the end of the propelling pencil to blend the shading.

5 Work briefly on the shoes. As a rule, the size of the foot should equal the full length of the head, so use this as a guide. Begin to add detail to the box and bag.

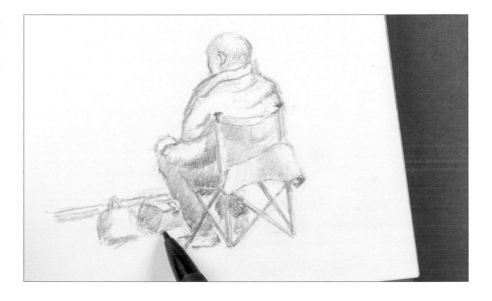

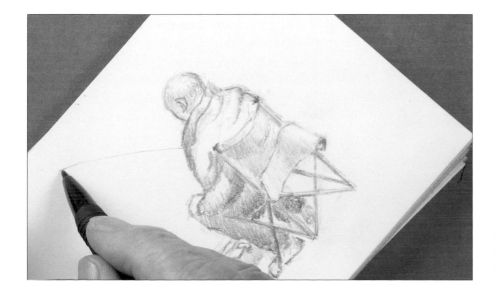

6 Draw the fishing rod in two lines. Each one should be drawn in one continuous arc.

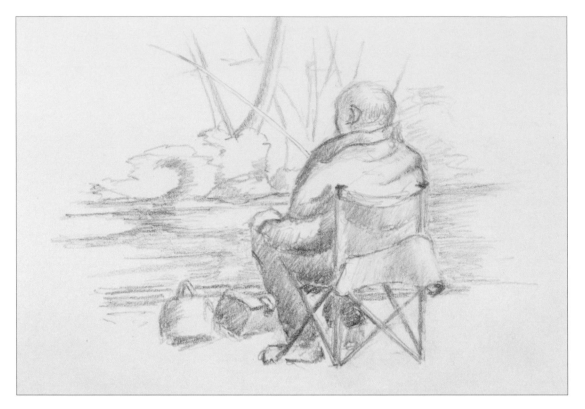

The finished pencil drawing. The background should be sketched in faintly, and the water drawn with horizontal strokes.

This drawing of Wimbledon Common was done on ordinary file paper with a 2B pencil and a stump.

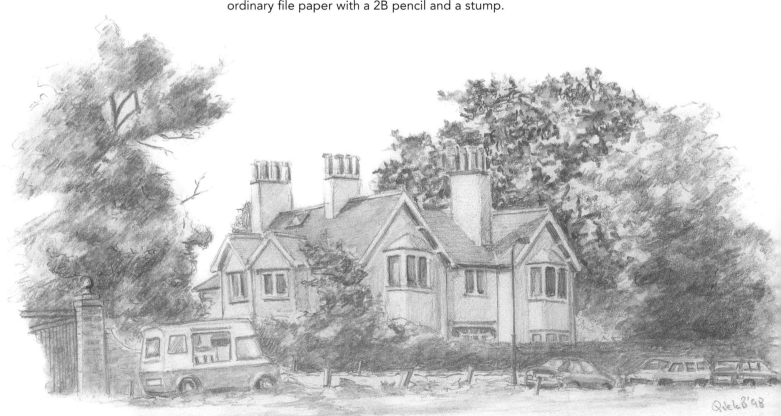

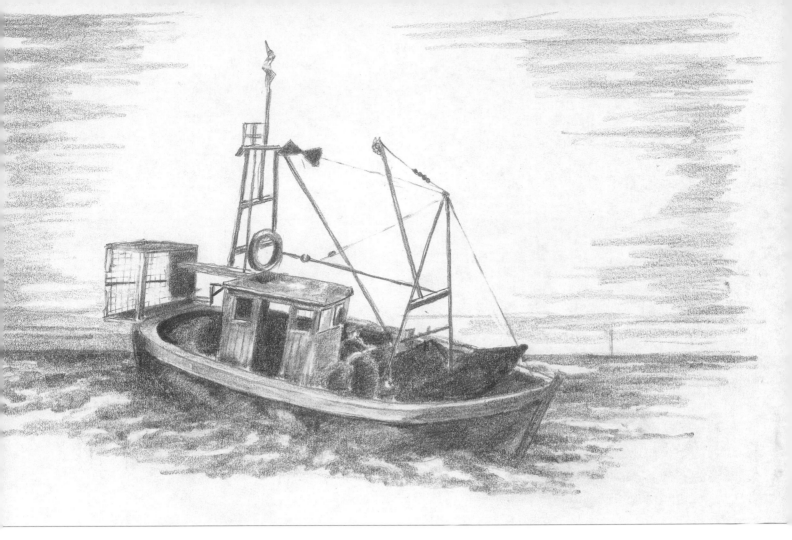

This drawing was done using 2B and 4B pencils, erasers and a stump on ordinary file paper.

Most museums forbid photography so I had to sit on a bench to draw this vase, which comes from the 9th century BC, making it the oldest object in this book. It was just under 36cm (14in) high. If you were ever under the illusion that ancient peoples could not produce truly beautiful objects, this should convince you. Look at the line and the finish! I marvel to think that I am somehow linked to the artist who saw the same beauty nearly 3000 years ago. I used a variety of soft pencils on 220gsm (100lb) paper, and my pencil-top wedge eraser. The putty eraser helped with the sheen. The drawing is shown here full size.

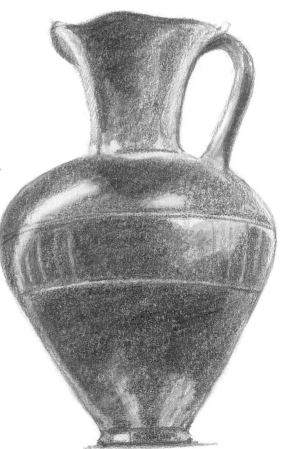

Richmond Park

Richmond Park, a few miles south-west of London, dates back to Charles I in the 17th century. On the whole it is too clean and well kept for me, but I liked this view of a stream running into the distance, and the natural composition was good.

I was more concerned with the relative size of the main trees and their relationship to each other than with accuracy so, once I had their main shapes, I was free with the detail. Many smaller branches and twigs are from my imagination. You will notice that the foreground tree has both its own shadow (showing the shape of the bank) and its own reflection in the water. At first sight you may not be consciously aware of the horizontal line of the background, but consider what it contributes to the composition.

You will need

Charcoal pencil
A4 cartridge paper
Ink eraser
Putty eraser
Stump

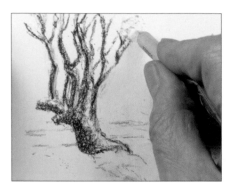

2 Start the detail at the top left of the drawing to avoid smudging your work with the heel of your hand. You can put a cross in the margins of the picture to remind you that the light is coming from the right. Shade the left-hand side of the more distant tree, and use the putty eraser to lift out highlights on the right.

1 Roughly draw in the main features of the compsition: the lines for the stream, the horizon, the large tree, the tree on the left and the lines of the fence. Note that the branches of a tree always get thinner as they split.

3 Work on the main tree. Shade the left-hand side darkly, then lift out light areas with the putty eraser to suggest the texture of the bark.

4 Put in the dark shading on the branches, leaving lighter areas on the right, and clean up the picture with the putty eraser.

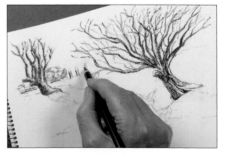

5 Add twigs to the main tree. Sketch in the background faintly, including the three distant trees, remembering to make the left-hand sides of the trunks heavier because they are shaded.

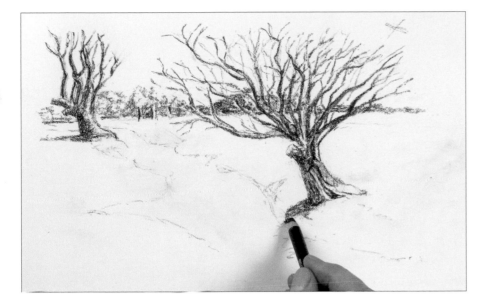

6 Avoid making regular marks, so that the background foliage remains natural looking. Make the background trees taller behind the main tree for variety. Put in the cast shadows from the two main trees. The shadow of the right-hand tree should indicate that the bank of the stream slopes sharply.

7 Draw in the edges of the stream. Lightly suggest grass across the park with rough, uneven marks.

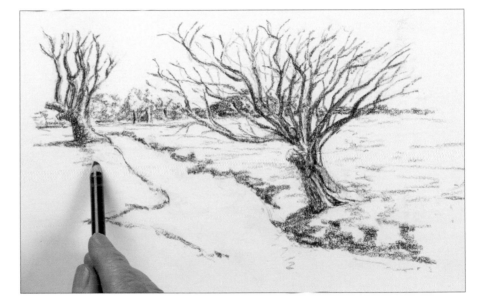

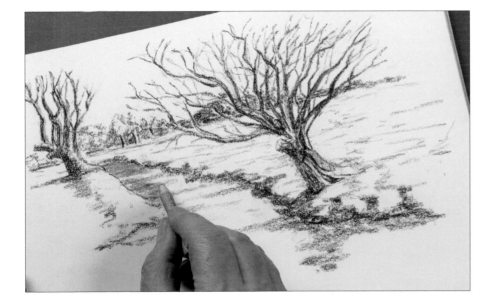

8 Work on the reflections in the stream. The shaded edges of the bank should be reflected in the water; the reflections will meld into the shaded banks themselves and become indistinguishable from them. Draw broken reflections with horizontal lines to imply ripples. Use the stump gently at the top of the stream where the shading is quite dark.

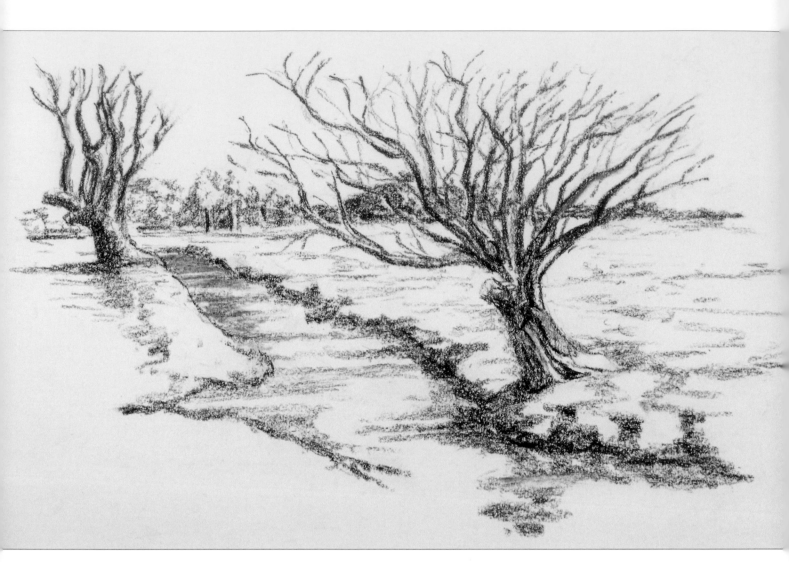

The finished charcoal drawing.

I drew this A5 picture of Richmond Park with a charcoal pencil and an eraser on 220gsm (100lb) paper.

Opposite

This indoor study was done using raw charcoal, erasers and a stump on file paper. Notice the perspective in this drawing. It is achieved partly by the relative size of the objects in the room (the magazines in the foreground would have looked distorted in a photograph). Perspective is also achieved by the horizontal surfaces, which vary in their relationship to the point of view of the artist.

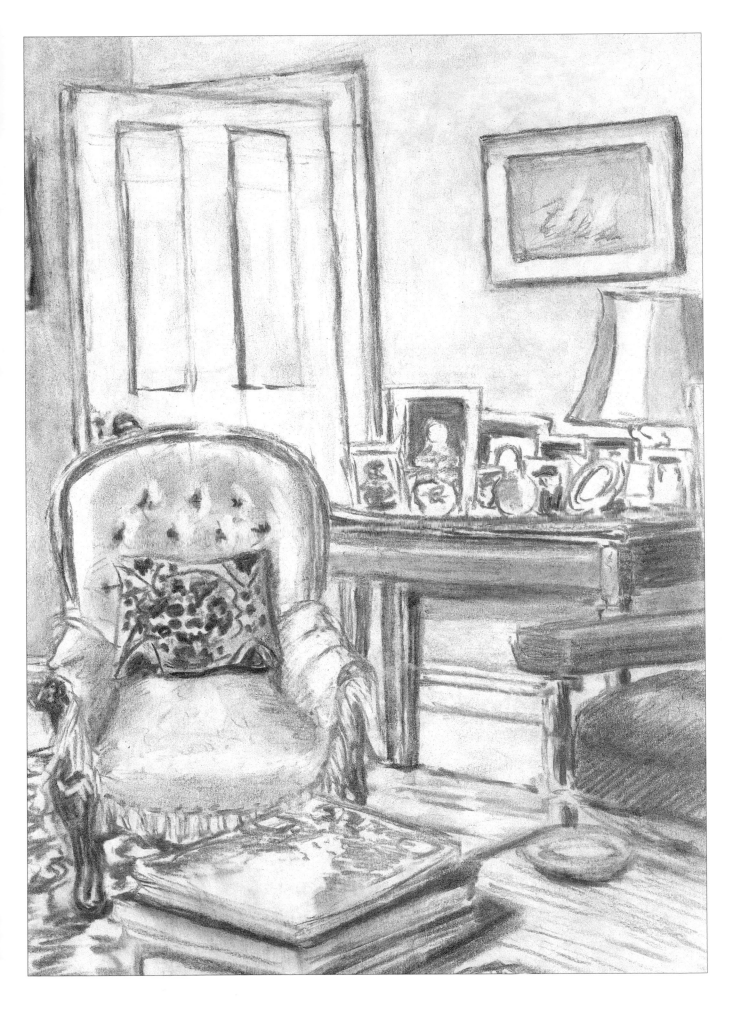

Old Woman

This old lady was to be found every day sitting in the same position against the wall of a church in Venice. I thought it would be an affront to her dignity to draw her directly, so I observed her carefully and drew from memory – checking every time I casually passed her. I broke my own rule and used my fingers where necessary – risking conveying acid to the paper.

Venice is a city with many aspects and we are all familiar with its beauties, but I wanted to capture an aspect, with its own beauty, that we do not often see.

You will need

Fine and thicker charcoal
Sandpaper
Cotton bud
Putty eraser
Paper tissue
Stump

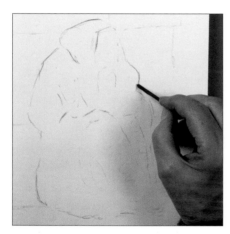

1 Sharpen the fine charcoal stick on sandpaper and draw a vague outline of the woman, as well as lines to indicate the stones of the wall behind her.

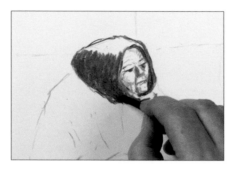

2 Add the main lines of the face and the shading, noting that the light is coming from the right. This is a face that shows real character.

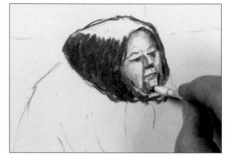

3 Use a cotton bud to blend and soften the face, which should not look too finished.

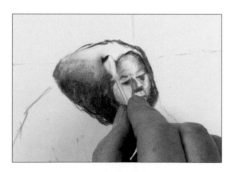

4 Use the cotton bud to soften the dark line of shading across the hood and to blend it into the highlit area.

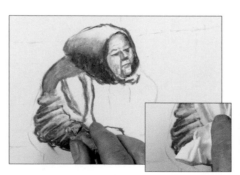

5 Using the thicker charcoal, draw in the line of the left-hand side, indicating the wrinkles in the sleeve and the shadow. Draw the hand roughly, without detail. Soften the shading with a cotton bud to imply drapery, and use a putty eraser to lift out highlights for where the light catches the creases. Soften the folds with a paper tissue, which works in a similar way to a putty eraser but picks up less charcoal.

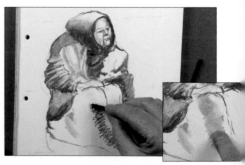

6 Draw the dark of the scarf coming down, and add vague wrinkles with a cotton bud. Blend with a stump. Work on the main lines of the drawing with the thicker charcoal. Put in dark shadow along the left-hand side of the leg, and smudge it with your finger.

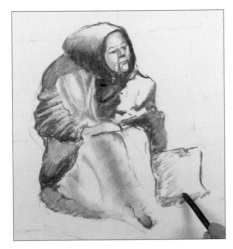

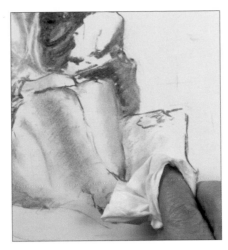

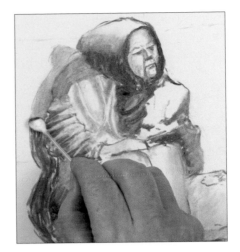

7 Add in more creases and smudge them, then darken them with more charcoal and smudge them again as required, to build up the look of drapery. Put in the dark at the bottom left of the figure and lighten it with a cotton bud. Draw in the bag on the right and shade the left-hand side.

8 Soften the shading with a paper tissue.

9 Put in the shadow of the old woman, slightly lower than her to suggest that she is leaning against the wall. Draw in the shading and soften it with a cotton bud.

Tip
It is often hard to distinguish the point at which an object ends and its shadow begins. Do not worry if there is not a clear line between them in your drawing: the viewer's eye will put it in.

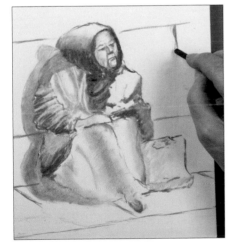

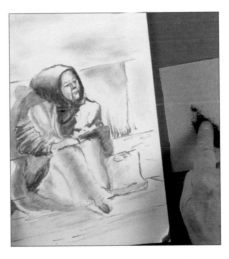

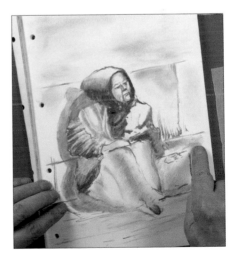

10 Draw in the lines of the flagstones, paying some attention to perspective: the three lines coming out from the wall should be at three slightly different angles. Draw the lines on the wall.

11 Apply a little charcoal to the ground and wall to indicate texture, and smudge it with your finger. Use your finger to pick up some of the charcoal left on the sandpaper used for sharpening.

12 Use your finger to apply this charcoal to the wall, suggesting a dirty, weathered surface.

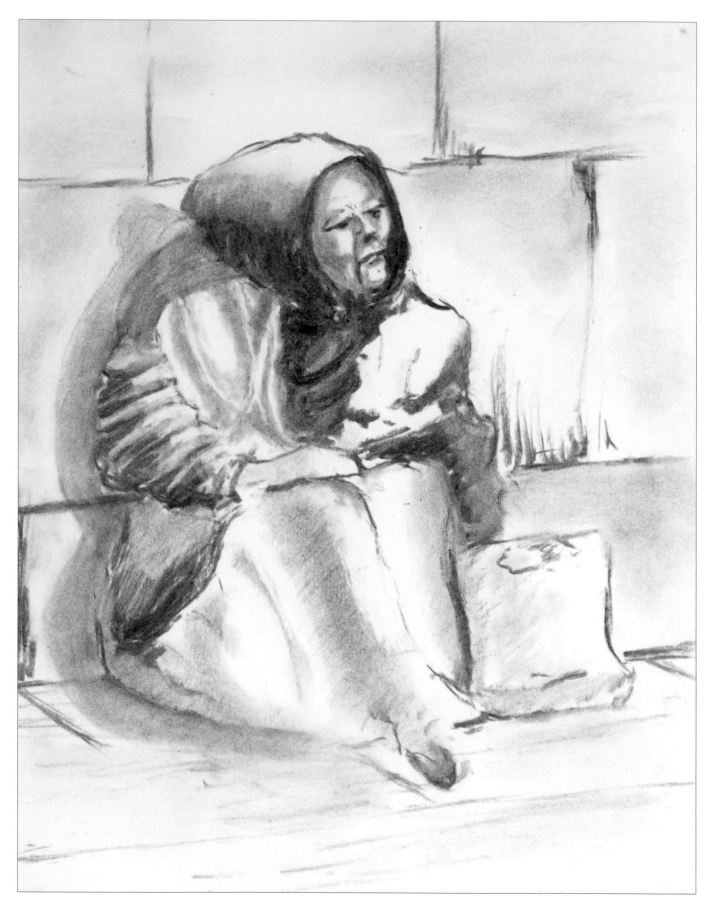

The finished charcoal drawing. To finish it off, I added vertical lines, smudged and tidied, added shape to the face and lifted out highlights with a putty eraser, as well as blending with a stump.

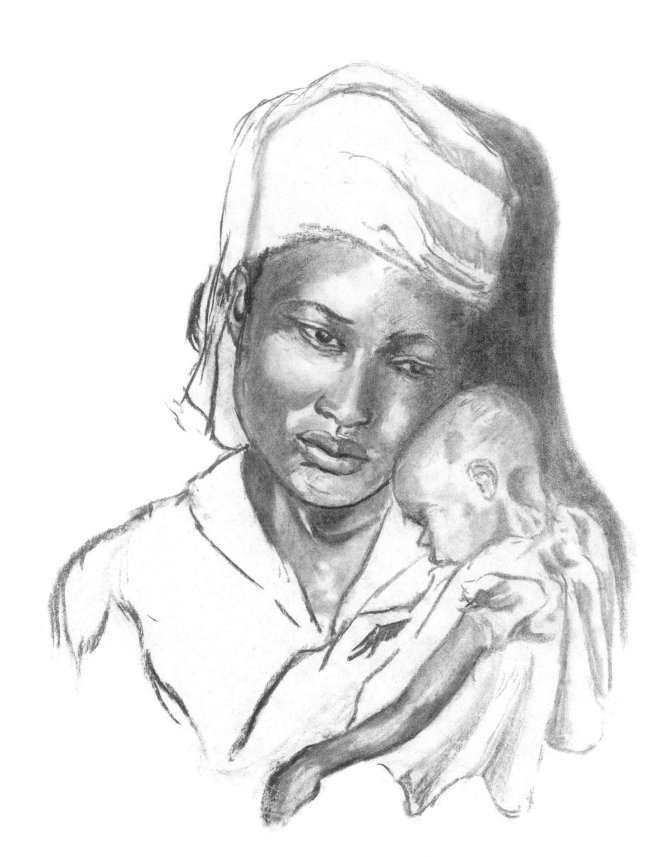

This drawing of a mother and child was done using charcoal, erasers and paper tissue on file paper. It shows how well charcoal can be used for expressing emotion in a drawing.

Farmhouse

I was passing this farm on my motorbike when I noticed that it was being demolished. With the permission of the foreman, I was allowed to sit in the farmyard recording a place that was important once and would never be seen again. Notice the care with which the details of tiles and bricks have to be treated – often using suggestion – if they are not to dominate the drawing.

You will need

Sanguine pencil
A4 file paper
Cotton bud
Putty eraser
Paper tissue
Pencil-top wedge eraser

1 Draw the main construction lines for the building, as well as axis lines to keep everything straight as you draw. Take care with the perspective on the main building and the chimney on the right; since these are at the same height, they should share the same angles of perspective. The bottom of the roof on the right is level with your eye line, so has no perspective, whereas the bottom of the house is below your eye line.

2 Draw the ridge tiles on the front triangle of the roof. As they get closer to your eye line, the distance between them should get larger because of perspective. Draw the tiles along the top ridge of the roof, making them uneven because this is an old building.

3 Draw the ridge tiles at the back of the roof. Add lines to suggest the roof tiles and use a cotton bud to blend them to the required shade. Draw in the odd whole tile, especially towards the bottom, and the eye will supply the rest.

4 Add sanguine shading to suggest discolouration of the tiles, and use a putty eraser to pick out lighter tiles.

5 Draw a little centre line just beyond the centre of the front face of the farmhouse, because of perspective. Draw the little window and the ridge of bricks. Put in the door, lower window and windowsill.

6 Draw in strong lines for the eaves and shade underneath. Darkly shade in the window, then use the pencil-top wedge eraser to lighten half of the area diagonally, to suggest glass.

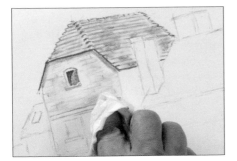

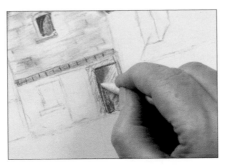

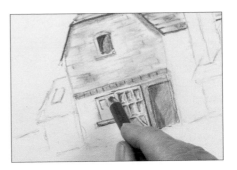

7 Draw in the odd brick to suggest the brickwork on the front of the house. Shade lightly all over the area, then rub with a tissue in places to soften and vary the effect.

8 Lift out colour from some bricks with a putty eraser. Draw in the band of bricks across the front, and the deep shadow on the lintel of the doorway and inside. Leave white for an unknown shape inside. Use a stump to blend the shading.

9 Draw in the constuction lines of the small windows in the door. Add the darks; you can adjust the size of the panes as you fill them in. Draw in the window on the left.

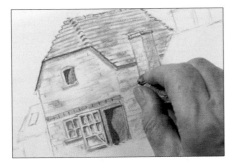

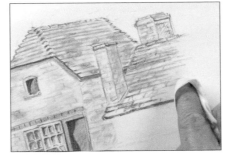

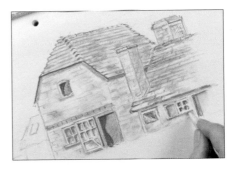

10 Add brickwork to the bottom of the house front and shade it. Work on the brickwork of the chimney and blot it with a tissue. Shade the darker side of the chimney. Lift out colour from the face of the chimney by pressing it with a putty eraser.

11 Work on the roof and the chimney on the right, and blot the shading with a paper tissue.

12 Draw in the little window on the right and the other details. Use the stump to blend and the putty eraser to lift out highlights.

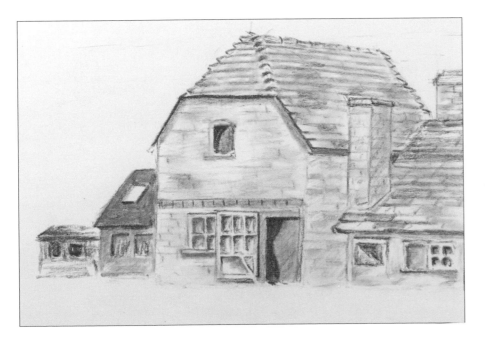

13 Work on the little buildings on the left. Shade the dark roof and blend it with the stump. Leave the skylight white, since it catches the light. Draw in the windows and darken them. Shade and blend the wall. Put in the building on the far left roughly and not too strongly, as it is far from the main focal point of the drawing. Darken the windows.

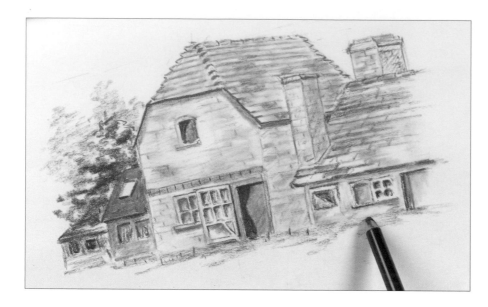

14 Suggest a background for the building by scribble shading foliage. Fainter scribble shading will suggest further distant trees. In front of the building, a few horizontal marks suggest the ground. Add a few uprights.

The finished sanguine drawing. At the last minute I remembered to add the little light on the front wall.

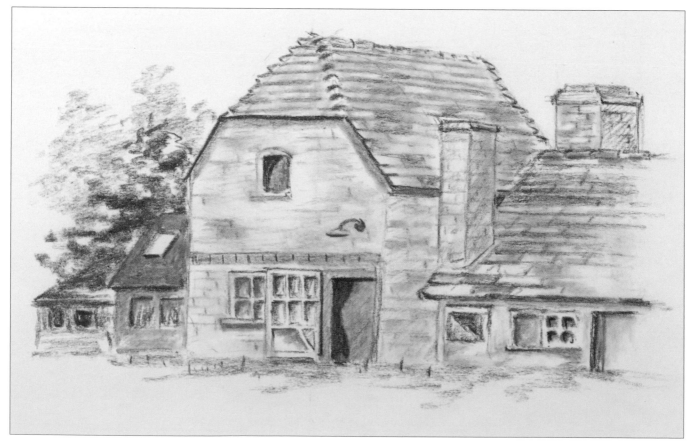

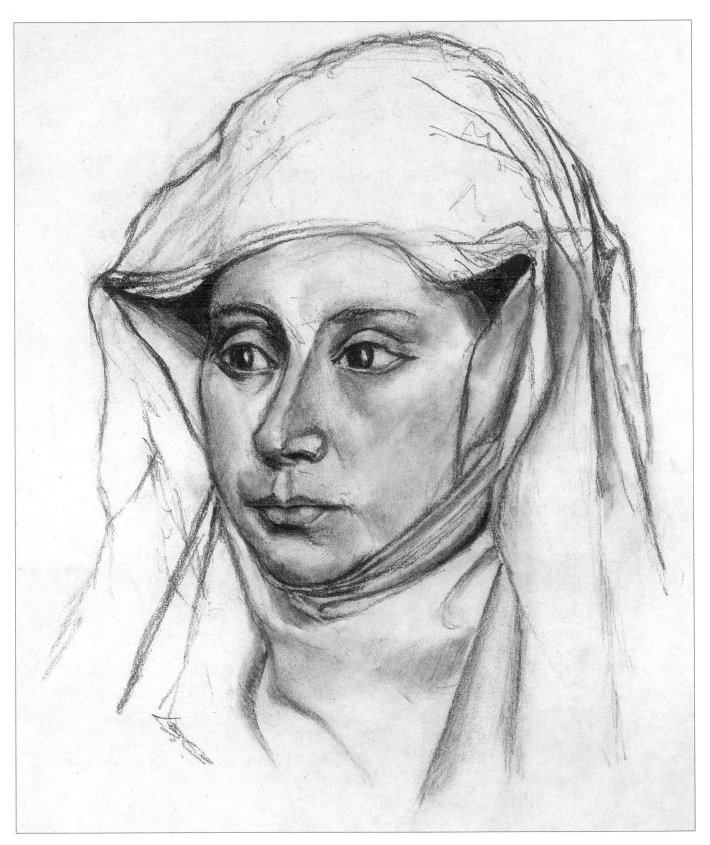

This sanguine study was inspired by Robert Campin's painting Portrait of a Woman (early 15th century), which is in London's National Gallery. It is one of the most beautiful paintings I know. I simply had to possess it — and now, through drawing, I do. I deliberately used it as an inspiration rather than a copy so that it would be truly, and uniquely, my own. Can one be in love with a woman who lived 600 years ago? I wonder.

Isabel

Quick sketches are often more lively than carefully finished drawings. In this case I did not see the need to draw the facial features, relying on the imagination of the viewer to assume them from the stance of my model. Stance is what this sketch is about.

There are plenty of guidelines for getting the proportions of the body correct, but the best is to observe them rather than assume them. Is your hand longer or shorter than your face? How do your feet compare? In what way does the line of the female hip vary from the male hip? Try using the head as a measuring mark. In Isabel's case, her head goes about six and a half times into her total height, and two and a half head-lengths take us from her chin to her waist.

You will need

Sanguine pencil
A4 file paper

1 Draw in the main structure or armature of the body loosely, holding the pencil further back than usual and making only faint lines. Be aware that the left breast will be high because the arms are above the head.

2 Strengthen the lines a little. Begin to shade, leaving highlights to suggest wrinkles in the tunic.

3 Continue shading down the right-hand side of the tunic. The shade down the centre should be lighter, to suggest a three-dimensional shape. The light is coming from the left.

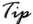

Tip
Sanguine pencil is harder to erase than graphite pencil or charcoal, so draw very faintly if you might need to erase marks at a later stage.

4 Draw in the legs, which are dressed in rather baggy trousers, and the feet. Add more shade under the folds in the tunic, suggesting the shape of the breasts.

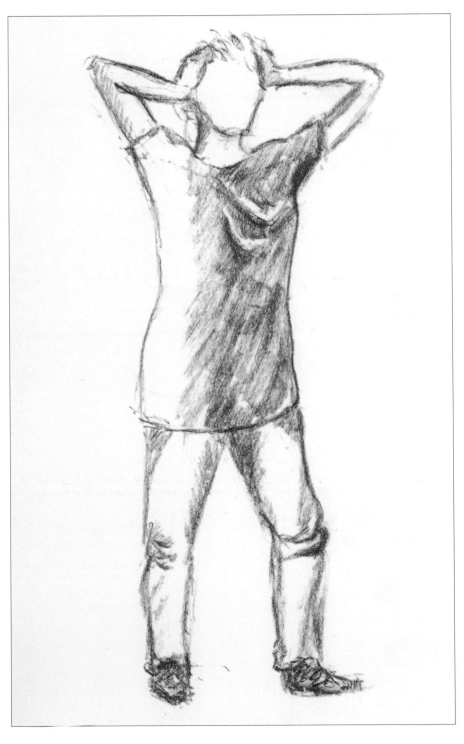

The finished sketch. I felt no need to add features to the face but left the sketch as it is, showing just the orientation of the head.

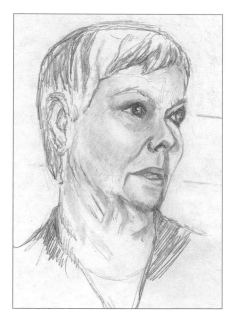

Judi Dench Portrait

A portrait is a very satisfying work of art. You are able to record, perhaps for posterity, an image of an individual which can show – at a deeper level than a photograph – the character of your subject. It can be frustrating too, because your subject may not see themselves from inside in the way that you see and interpret them from the outside. You just have to live with that. It is also a real challenge which will require every technique you have learned in this book.

For this exercise I have chosen a well-known face because, unless one has a special purpose in mind, a portrait needs to be a good likeness – and so you will be in a position to judge the result. I heard a student ask his very experienced tutor how one obtained a likeness, and he replied simply, 'Get the right features in the right place.' Good advice, and so that is where I start.

You will need

B pencil
Putty eraser
File paper
Tracing paper marked with 1cm squares
A4 cartridge paper
Sanguine pencil

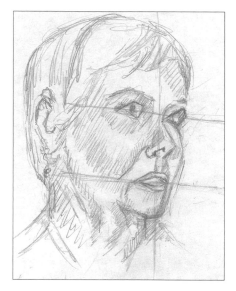

1 My initial sketch is rough indeed. I use the cheapest paper and a B pencil, and work away firmly, putty eraser at the ready. I start by drawing axis lines, and continue by building in the features. I need some tethering points, and I prefer to use the eyes because it is easier to judge their size, and the distance between them. Using them as a measuring rod I build in the other features: how far to the tip of the nose, where does the corner of the mouth come etc? I am ruthless with the eraser until I am satisfied with my positioning. At this point I start identifying shadow, and find that screwing up my eyes helps me with this. Then I hatch the shadow in – with no subtlety. The drawing is about 10cm (4in) high.

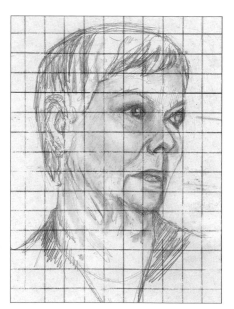

2 This not much of a likeness yet, but it is sufficiently close to take on to the next stage. Working directly on to my rough sketch, I produce the next stage. I am reasonably happy with this. In fact, with some cleaning up and refinement of detail, I could leave it as finished for my purposes. But these are not my purposes: I want to increase its size and do a finished portrait in sanguine pencil, which I think suits the subject. My preparatory sketch has familiarised me thoroughly with the head: I know its shape, and I know its detail – but I do observe that I have the mouth line slightly wrong.

3 Next I produce the same sketch, reticulated with 1cm (3/$_8$in) squares. I cheat a bit here because I keep a transparent envelope with the squares already marked, and place it over the existing sketch.

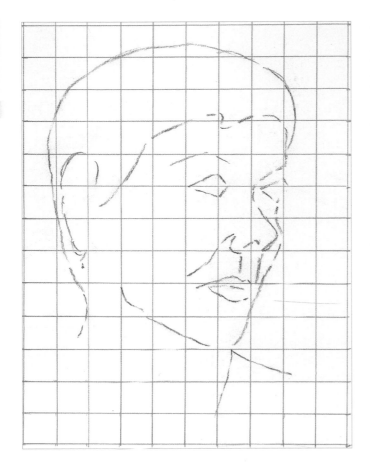

4 Next, I lay out my quality drawing paper (cartridge A4), this time with 1.5cm (5/8in) squares, and on it I copy the vital detail in lightly drawn sanguine pencil. This is now one and a half times as large. I could, of course, have enlarged or shrunk my picture by using different sized squares. This 'squaring up', used for changing the size of a picture, goes back at least as far as the tombs in ancient Egypt. However, if you have a scanner (or digital camera) and a computer and printer, you may be able to print out your initial sketch directly, in the size you want. Then use tracing paper to transfer it on to your drawing paper.

5 By now, in fact, the hard work is done. Completing the portrait requires the other skills I have discussed: minute observation, good line and careful attention to shading (much helped by understanding the underlying anatomy). This is a beautiful and mature face, so my result must be closer to what the viewer sees than the more harsh visual analysis of the artist's eye.

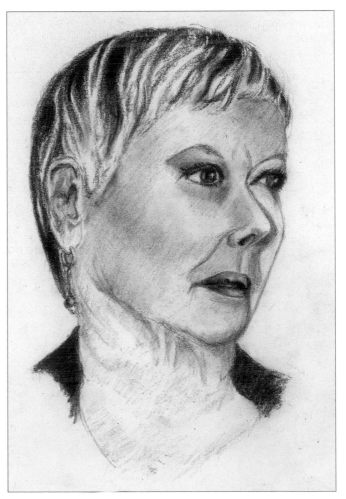

The finished portrait. While what I have described in the steps sounds like a mechanical process, it is far from that. The portrait you have produced is a likeness infused by the knowledge, sympathy and creative interpretation you have brought to the work.

61

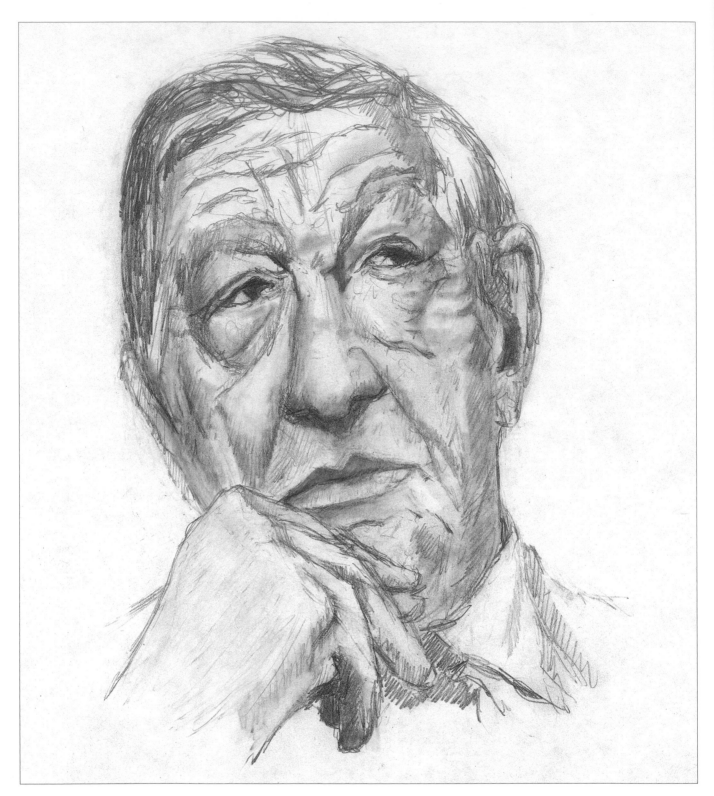

The other portraits shown here are carefully finished. This one, of the poet, W H Auden, is carefully unfinished. He has a spendidly craggy face, which shows intelligence and sensitivity, so I chose to draw him with craggy lines and a deliberate roughness of treatment. However, I followed my usual route of drawing axis lines and getting a very close likeness.

I needed his hand (and the angle of his gaze) to show that he is thinking, perhaps a little warily, about the answer to a question. However, had I finished the hand, it would have distracted from the face, so I left out any detail here. In drawing, as many of my examples show, less is often more.

The portrait was drawn on A4 file paper with a 2B pencil.

This portrait of Rudolf Nureyev dancing 'Le Corsaire' was done with sanguine pencil,
touched with brown and black pencil, and erasers on 300gsm (140lb) watercolour paper.

Index

This drawing was done at Heathrow airport while waiting for a flight.